JOHN DICKSON BATTEN

Illustrations for Dante's *Inferno*

Introduction and Commentaries by Peter Hainsworth

Published by Panarc International 2021

www.panarcpublishing.com

ISBN 978-1-9161566-6-1

I. M. George Musgrave (1855–1932) who commissioned these
illustrations for his translation of Dante and subsequently left them to
Lady Margaret Hall.

CONTENTS

PREFACE

One of the main corridors in the Deneke Building in Lady Margaret Hall is known as Hell Passage. Its walls are nowadays covered in notice boards, but its name comes from the fact that for decades it was hung with illustrations to Dante's *Inferno*. These were created in the late 1890s by the artist John Dickson Batten (1860–1932) and left to the college by George Musgrave (1855–1932), who commissioned them. They were intended to accompany the second edition of Musgrave's translation of the *Inferno*, which finally appeared in 1933, a year after the deaths of both Musgrave and Batten, and which quickly vanished into general oblivion.

A similar fate awaited the drawings themselves. Since being taken down, they have been filed away in Lady Margaret Hall Library, unseen by members of the college, let alone the wider public, and are unknown even to specialist art historians. This book and the exhibition that accompanies it are timed to coincide with the 700th anniversary of Dante's death, and aim to remedy the neglect which has dogged the drawings effectively since their creation. They are perhaps the highest achievements of an innovative and accomplished artist who enjoyed a considerable reputation in his own time and has been undeservedly forgotten. They also offer remarkable visualisations of Dante's poetry which anyone approaching the *Divine Comedy* for the first time can enjoy and benefit from.

Reproduced here is the full sequence of forty-five drawings, with translations of relevant passages in the *Inferno* which Batten almost certainly had in mind, and short explanations of what each drawing represents. An appendix contains two maps of Dante's world by another artist, Edmund Hort New (1871–1931), which Musgrave also commissioned,

and a portrait of Dante by Frederic, Lord Leighton, which Musgrave thought of using at one stage as a frontispiece for his translation. These, too, are part of his bequest to Lady Margaret Hall and are as unknown as the Batten drawings.

I am deeply grateful to the Principal and Fellows of Lady Margaret Hall for permission to reproduce the illustrations and for financial support from the Dale Fund for Renaissance Studies. I owe particular debts of gratitude to various members of the college: to Anne Mullen for smoothing the project's progress; to Roberta Staples and Oliver Mahoney for invaluable help with library and archival material; to Allan Doig and Nicholas Shrimpton for expert advice and encouragement; and above all to James Fishwick, the present college librarian, who photographed and scanned all the illustrations in their various forms with great efficiency and care, and helped me select which versions to use. I am grateful, too, to David Robey for reading and commenting on the Introduction and the translations with his usual acumen, and to Anne Marshall for her fresh, enthusiastic and acute comments on the images themselves. For her professionalism, skill and sensitivity in the design and setting of the book, I must express my heartfelt thanks to Averill Buchanan. I am also deeply and happily indebted to Paul and Stephanie Georgiou at Panarc Publishing, without whose open-minded thoughtfulness, generosity and practical sense this book would almost certainly never have got off the ground. Nor would it, if the love, intelligence and humour of my wife Jane had not supported me at every stage. I cannot thank her enough.

Peter Hainsworth
Oxford, March 2021

INTRODUCTION

John Dickson Batten was born in 1860 in Plymouth. His father was a QC, and he too seemed bound for a legal career: he took a degree in law at Trinity College, Cambridge and was admitted to the Inner Temple in 1884. But he soon changed direction completely and trained as an artist at the Slade School under the French painter, Alphonse Legros.

Batten went on to have considerable success as a painter but he became better known as a book illustrator. He worked principally with Joseph Jacobs, a campaigning Jewish scholar who was also a leading folklorist. Batten illustrated most of the collections of folk-stories and fairy tales that Jacobs put together in the 1890s, from *Celtic Fairy Tales* (1890) to *The Book of Wonder Voyages* (1896), most of which are now accessible online. His style in these is characteristically Gothic and fantastical, as one might expect. But his interests kept expanding. He explored different techniques of printing and was one of the prime movers in the introduction of Japanese wood-block processes into England. He was also drawn to early Italian art and poetry and produced a set of illustrations for *A Masque of Dead Florentines* (1895), a sequence of aestheticising rhyming verses by the novelist Maurice Hewlett on great Florentine writers and painters of the Middle Ages and Renaissance. One of the first illustrations shows Dante's Beatrice, Petrarch's Laura and Boccaccio's Fiammetta dancing together, with Death in the foreground playing a lute; another shows Dante, Petrarch and Boccaccio together. Then follow portraits, mostly death-haunted, mostly of artists, from Giotto to Michelangelo.

The step from here to illustrating Dante was not, therefore, a large one. The person who drew Batten into taking it was

George Musgrave, a graduate of St John's College, Oxford, and a well-off lawyer who published a version of the *Inferno* in 1893, with the intention, never realised, of following it up with *Purgatory* and *Paradise*.[1] It was by any standards an unusual translation. Its form is the nine-line stanza that Spenser had used in the *Faery Queen*, in iambic pentameters rhyming ABABBCBCC, with a twelve-syllable final line. No other translator, before or since, seems to have thought this was an appropriate way of capturing something of Dante's *terza rima* in English. And Musgrave went further. Though he managed to keep surprisingly close to the sense of the original, the idiom he chose was also Spenserian, with a rich patina of archaic poetic words and a correspondingly archaic poetic syntax. Perhaps unsurprisingly, the translation was not well received, and Musgrave himself was dissatisfied with it. He set about revising it for a second edition that he seems initially to have hoped to have ready within a few years. He also decided that it should be illustrated, and commissioned John Dickson Batten as the illustrator.

Over a period of three years, between 1897 and 1900, Batten completed forty-five pen-and-ink drawings of scenes from the *Inferno* for Musgrave. Forty-three were exhibited at Leighton House in London in January 1900[2] and then passed to the printer Richard Taylor for plates to be prepared. However, for reasons that we do not know, publication of the second edition of the translation was to be long delayed, though a number of prints of the illustrations were made over the next few years. These were in the form of collotypes, a type of photographic reproduction using gelatin invented in the mid-nineteenth century and for some decades commonly used for book illustrations.

At some point Musgrave decided to commission another series of illustrations from another artist, Edmund Hort New, whose speciality was rural and urban scenes. New

[1] *Dante's Divine Comedy, Consisting of the Inferno-Purgatorio and Paradiso. A Version in the Nine-line Metre of Spenser, by George Musgrave. The Inferno or Hell.* London: Swan, Sonnenschein and Co., 1893.

[2] Those exhibited were reproduced in the *Catalogue of an Exhibition of Forty-three Drawings by John D. Batten Held at Leighton House, Whitsuntide, 1900. A.D.* (Long Acre: David Nutt, 1900), and then again in 1900, in *Dante's Inferno: Forty-three Illustrations by John D. Batten*, Engraved by Richard Taylor and Co.

accompanied Musgrave and his wife to Italy in the autumn of 1913 and, over the next few months, produced a substantial set of drawings of places connected with Dante and the *Divine Comedy*, plus others of coats of arms of noble families of Dante's time. He also drew the maps of Hell and of Dante's world overall, included in the Appendix here. Musgrave himself appears to have thought of incorporating at least some of New's work in the second edition alongside, or instead of, Batten's illustrations. He also intended to include as a frontispiece a portrait drawing of Dante by Lord Leighton (see the Appendix). In the event, when the second edition did eventually appear, it included forty-four of Batten's drawings but nothing by New, nor the Lord Leighton portrait.

That was a long way into the future. Apparently because of ill health and eventual blindness, Musgrave was never able to carry out the revisions to his full satisfaction. It was only in 1933, a year after both he and Batten had died, that the second edition, complete with all but one of Batten's illustrations, was finally published, the final editing of the text being completed by Edward Adams Parker, an Oxford friend of Musgrave and an executor of his estate.[3]

For all the tinkering the text was not significantly improved. Here is the stanza recounting the moment when Dante is recognised by his old teacher, the Florentine writer Brunetto Latini (*Inferno* 15.25–33), now punished in Hell for sinning against nature (that is, sodomy), by having to run for ever with a host of other similar sinners under an unrelenting rain of fire.

> Then stretched he out his arm to me, whilst I
> So fixedly scanned his baked lineament,
> That, albeit scorched with fire so terribly,
> It baffled not remembrance. So I bent
> My face to his, and back this answer sent:
> 'Oh, Ser Brunetto, art *thou* here?' And he:
> 'Nay but, my son – ah! be not ill content
> If Brunetto Latini back with thee
> Turn for a little space, and quit this varletry.'

3 *Dante's Inferno. A Version in the Spenserian Stanza*, by George Musgrave, with *Forty-four Illustrations by John D. Batten*. London: Humphrey Milford [for Oxford University Press], 1933.

Some of the archaising has gone but the style and idiom remain much as it was. Even in 1933 Musgrave's version must have seemed distinctly old-fashioned.[4] Such critical notices as appeared acknowledged the hard work that had gone into the translation but were distinctly unenthusiastic about the results. One reviewer opined that the overall effect was 'ridiculously remote from Dante' and that while Musgrave's literary skill was considerable, poetry 'does not derive from literary skill.'[5] Later judgements are only slightly less damning. Musgrave quickly vanished from sight. After some hesitations, I decided that he was simply too unapproachable to be resuscitated alongside Batten here and have used my own translations, which aim to be more functional than anything else. The interested reader can compare the stanza above with my version on page 68.

The Batten drawings were also eclipsed. Reviews of the Musgrave translation mention them only cursorily, if at all, and, unlike the illustrations to fairy tales and folk-stories, they had no literary context in which they might subsequently reappear. Unlike many other drawings by Batten, they are not available on the web. But they had not vanished. For reasons that are again not clear, Musgrave left in his will all the Dante material he owned to Lady Margaret Hall, Oxford. It included Batten's original pen-and-ink drawings, multiple copies of the collotype reproductions, the wooden blocks from which copies were made, as well as the original New drawings, and copies of the Leighton portrait. In the year following Batten's death the drawings were loaned at the request of his widow for an exhibition at the Art Workers Guild. It was the last time they were made available for viewing by a wider public. Thereafter, the only display was in Lady Margaret Hall itself, where a selection of the collotypes hung for years along the walls of one of the corridors in the main building, which

[4] The decade 1928–38 saw five translations of the *Inferno* published and two of the entire *Comedy*. For details, see Gilbert Cunningham, *The Divine Comedy in English. A Critical Bibliography* (2 vols. Edinburgh: Oliver and Boyd, 1965–66), vol. 1, p. 9.

[5] The review, by W. J. Turner, appeared in the *New Statesman and Nation* (23 July 1933). For a summary of initial reviews, see Cunningham, vol. 1, pp. 186–91, and for later ones, William J. De Sua, *Dante into English. A Study of the Translation of the Divine Comedy in Britain and America* (Chapel Hill: University of North Carolina Press, 1964), pp. 26–39.

has continued to be known as Hell Passage long after the pictures were taken down and replaced by noticeboards.

Even Lady Margaret Hall seems to have been unenthusiastic about its inheritance, perhaps understandably so, up to a point. The original drawings were mounted, presumably for the 1900 Leighton House exhibition, in some cases with additional touching up in white or green, but the mounts are discoloured and ragged and some of the drawings are not in good condition. As for the collotype reproductions, a letter from Parker (Musgrave's executor and editor) to the Principal of Lady Margaret Hall, dated 16th January 1933, says that they 'can be regarded as valueless', though he does say that the original drawings are valued at £80.4s.6d.[6] Apart from those collotypes displayed in Hell Passage, both sets ended up filed away in a library cabinet, almost entirely forgotten until very recently.

Parker was wrong to be dismissive of the collotype reproductions. Whatever their monetary value, they are arguably, alongside some of the mounted drawings, the best realisations of Batten's Dante work. The versions that appeared in the second edition of Musgrave's translation are necessarily on a much smaller scale and tend to blur the gradations of line and shading that characterise the collotypes and were Batten's especial forte. The original collotypes, almost all in multiple copies, are in good condition. Most are on stiff white paper, with further copies, in some cases more than one, of almost all the images on finer off-white paper, dated to 1912–3, these being perhaps intended for some further exhibition that almost certainly did not take place. The images for this book have been taken from the collotypes on white paper, which arguably present the fine lines in Batten's work with most clarity and accuracy.

* * *

We tend to think of nineteenth-century English artists, especially the Pre-Raphaelites, as eager and prolific illustrators of Dante. In fact, most picked on episodes from Dante's life, particularly ones deriving more or less fancifully from the *Vita nova*. Illustrations of the *Divine Comedy* are much less

6 Lady Margaret Hall (hereafter LMH), Domestic Papers Box 3, Musgrave Bequest.

numerous and concerted sequences rare. Before Batten, only two British artists of any stature produced Dante illustrations in any numbers. The first, John Flaxman, made 110 neoclassical drawings covering the whole *Divine Comedy* towards the end of the eighteenth century, when Dante was just beginning to emerge from a long period of neglect, even of downright hostility. These were much reproduced throughout Europe and were highly rated by other artists. Much less known in his own time was William Blake, not only for his many Dante drawings but for his work as a whole. In any case, Blake's drawings say much more about his own imagination and concerns than about Dante and are not what we normally think of as illustrations of a literary text.

For the general British public, caught up in the interest in Dante that kept increasing throughout the nineteenth century, the illustrator who really mattered was Gustave Doré, the prolific French artist who illustrated Milton, Homer, Byron and many other canonical authors. It was his Dante drawings, especially those for the *Inferno* (which far outnumbered those he did for *Purgatorio* and *Paradiso*) that were particularly successful. In Britain they were regularly reproduced from 1866 onwards in editions of Henry George Cary's *The Vision of Dante*. This translation, once Samuel Taylor Coleridge had given it his stamp of approval in 1815, became the most widely read version of the *Divine Comedy* in nineteenth-century Britain and has continued to be reprinted, with the Doré illustrations, up until today. As a result, generations of English readers have seen Dante through or alongside Doré's dramatic, perhaps melodramatic, visual imagination. He was an immensely talented artist, but he undoubtedly contributed a great deal to the common (and mistaken) view of Dante as possessing a darkly pessimistic, tormented, even perverse vision of humanity.

That Batten approaches Dante in a much more balanced, even calm, way is undoubtedly one of the reasons why his illustrations found such a poor reception among critics with a Romantic taste for horror, disturbance and conflict. In that regard he was pictorially closer to Flaxman, as he was in his deployment of line. But Flaxman, and for that matter Doré, were decades in the past by the late 1890s when Batten was working on the *Inferno*. More recently there had been the Pre-Raphaelites, and the developments associated with the

terms Art Nouveau, Symbolism and Decadence, all of which are picked up in Batten's work generally. We might point also to the clear formal contrasts between light and dark areas in many of his illustrations, which derive ultimately from the intense interest he shared with several of his contemporaries (most notably Aubrey Beardsley) in Japanese printing techniques and practices.[7]

But Batten was his own man and, what is more, in his Dante illustrations he moved on significantly both from what he had done as an illustrator of folk tales and fairy tales and from the more classicising images of the *Masque of Dead Florentines*. In the first place he obviously read his Dante with great care and was determined to pay attention to the rich complexities of Dante's writing. He also took into account its underlying patterns of thought in a way that previous English illustrators had not done to anything like the same degree.

Though Dante himself ultimately sees Hell as a place of falsehood and illusion based on a sinful rejection of divine transcendence, he gives to it a concreteness that can make it seem almost as real to the imagination as the world in which we normally live. The punishments may be horrific, but they are enacted in a place which has a complex (if flawed) structure to it and has the material hardness of a destroyed city in some dark, barren landscape. Rather than emphasising horror and desolation (as Doré had done), Batten picks up these primary features of Dante's poetry. His Hell is a place of fissured pavements, massive boulders, rough walls and bridges, and enormous rocky cliffs, any and all of which are given prominence in one drawing after another. Through strong and careful texturing of the surfaces represented, the drawings create a sense of the dark materiality of Hell, reflecting Dante's underlying conviction that sin is ultimately a turning away from light and the spirit towards matter in its most inhuman and unfriendly form.

Then some of the most impressive drawings – such as the flight down on the back of the monster Geryon (no. 27) or the view of the whole of Hell from above Satan's head (no. 43) – present vast overviews. Partly through showing figures such

[7] Batten published an article, 'Woodcut Printing in Colour after the Japanese Manner', in *The Studio,* 3–4 (1894–5), pp. 110–15 and 144–48.

as the giants on a vastly reduced scale, Batten emphasises the sheer extent of the place, as well as depicting with great precision the way in which the different circles are configured. Things do not happen in a void as they do in Flaxman, or in a generalised infernal landscape, as they tend to in Doré.

Batten characteristically works from a precise passage in the text, while often including (as in the Geryon drawing) other features that may not be mentioned explicitly in the episode in question. Often the moment is a highly dramatic one, as when the hesitant Dante is told by his guide, Virgil, to break off one of the branches on a thorn tree containing the soul of the suicide Pier della Vigna (no. 23), or when Dante cowers back into Virgil's arms on being suddenly addressed by the soul of Pope Nicholas III, plunged upside down in a hole like other corrupt members of the clergy and shaking his blazing feet in Dante's direction (no. 29).

Though the illustrations cover almost every canto in the *Inferno* in one way or another, Batten's focus is on the narrative of Dante and Virgil's journey and what they see. He makes no attempt to represent the stories the characters tell, let alone discussions between Dante and Virgil. The whole of canto 11, for instance, is given over to an explanation by Virgil of the structure of Hell, justified in the story by the need for Dante to stop awhile to become accustomed to the stench rising from the circles of Hell they are about to enter. In Batten, all we see are two minute figures in the background of a picture dominated by the Minotaur (no. 20). It is similarly the figures of Paolo and Francesca that he focusses on in numbers 11 and 12, albeit in a highly poetic and evocative way, while in other cases, famous characters such as Ulysses (no. 36) and Ugolino (no. 41) occupy only a small part of the pictorial space. If this means that some of the most poetic parts of the original are reduced or eliminated, it also means that Batten brings the essential narrative and its context before our eyes in a remarkably forceful way.

Throughout the series Batten draws the figures of Dante and Virgil with simple lines, correctly making them figures of light in the general confusion and darkness of Hell. His Dante is dressed in a scholar's gown and hood, as is traditional in Dante illustrations, but he is a young-looking figure, not the fierce one with the aquiline nose and lean cheeks that we are more familiar with. Batten is perhaps working here

from the portrait discovered in the nineteenth century and ascribed at the time to Giotto. His Virgil is more traditional – an older, bearded figure in a long robe – whom the viewer can readily accept as the ancient poet Dante knew best and most admired. Virgil always looks serious and Dante always observant, but their faces show emotions only schematically. Emotions appear rather in positions and gestures, very often with a deliberate lack of explicit drama. The effect is to invite the viewer to pause and reflect on what is going on in the image as a whole. As with much Art Nouveau, the lesson of Japanese art is immensely positive.

There is of course movement, strong emotion and often poetry too in many images, particularly where the emphasis falls on the damned or their guardians. Batten's Cerberus and Pluto (nos. 13 and 14) look back to his illustrations of folk and fairy tales, as even more do his devils struggling with each other to get back into the City of Dis (no. 17) or threatening and squabbling further down (nos. 31 and 32). The effect there is one of grotesque comedy of the kind that Dante himself creates at that point. Conversely, Batten's Geryon circles down over Hell in a strangely serene way, and Paolo and Francesca (no. 12) come towards Dante as if they are dancing through the black air. Or take the avaricious and prodigals (no. 15) pushing their enormous boulders, where Batten represents directly the physical efforts and the shouting of the sinners, or the thieves (no. 35) undergoing various transformations watched by a horrified Dante. In these latter two images Batten is particularly careful to represent as accurately as he can the action or actions that Dante describes.

Though everything depicted is in Dante, the image of the thieves has arguably too many different things going on in it to be completely satisfactory pictorially. The representation of the avaricious and prodigals is more focussed and for all its movement retains an element of stillness, particularly in the naked figure in the foreground. Here, we may feel, is an element of posedness, of decorativism. And we may find more of that elsewhere. Brunetto Latini (no. 25), Dante's teacher and a leading member of the previous generation of Florentine intellectuals, looks unexpectedly youthful, with his arm raised almost as if he were a model in an art class rather than a damned soul making a gesture of response to Dante's reaction on recognising him. Clearly, here and

elsewhere – for instance, in the figures of Farinata (no. 19) and Jason (no. 28) – Batten has decided that those complex and striking figures for whom Dante shows great respect, or even sympathy, in his poem, are best represented visually in a classicising vein which does not so much demean as elevate the figure in question. The classicism is particularly evident in the encounter and conversation with the ancient poets, the 'bella scola' of Homer, Virgil, Horace, Lucan and Ovid, to which Dante is himself admitted (no. 9). Not only are the poets depicted in the same outlined manner as Dante and Virgil, and the whole scene suffused with light (as it is in the text), but two of the poets, Horace and Lucan, are at least as youthful-looking as Batten's Dante. The implicit visual suggestion is that Dante is indeed one of them and that it is appropriate for him to be admitted to their company.

Perhaps more startling are his giants (nos. 39, 40, 43), who are terrifying in the text, but in Batten's images are almost Michelangelo nudes, cast in languorous poses rather than tormented ones. What the images do suggest, however, is the classicism of the literary culture which Dante's similes and idiom evoke at this point, rather than intimating in any way that these giants are anything like the ogres of Northern mythology. Batten is again, in fact, staying close to Dante in this regard, as he is in other ways too. These three illustrations in which the giants appear are also among Batten's most brilliant realisations of contrasting scale. In the first two images in which they appear, the visual impact derives from their sheer size in relation to the landscape of Hell and to the figures of Dante and Virgil, while in the third image Batten (like Dante) emphasises their smallness in relation to the figure of Satan.

Other figures, too, echo and reverberate against each other, most powerfully Batten's Beatrice (no. 4), Dante's entirely virtuous beloved, and his version of the two damned lovers, Francesca da Rimini and her brother-in-law Paolo (no. 12). The latter pair were a favourite subject of nineteenth-century painters and illustrators, mainly for the opportunity they offered to represent a refined erotic passion which Dante was himself drawn to. Doré devoted five images to Paolo and Francesca; the Dutch-French artist Ary Scheffer was so successful with his paintings of them in each other's arms that he returned to the subject some eleven times altogether.

Batten's first image of the lovers shows them emerging from the general throng of lustful souls (no. 11), and then his more impressive second one (no. 12) takes up and varies in a distinctive way what was by now established nineteenth-century iconography. Floating above Dante in the black air, encircled by the arms of her beloved Paolo, Francesca is a youthful, almost demure figure, in spite of her nakedness and wispy veil, and the lovers together seem as light on the wind as Dante says they are. But the sexuality is evident, however refined she may seem, and the landscape and darkness make it evident that where the lovers are is Hell. Beatrice, on the other hand, appears in one of the first images in the series,[8] looking down from heaven on Dante struggling futilely to climb the hill of virtue and knowledge by his own efforts. She is clothed and chaste in her concern for Dante. But her features are almost identical to those of Batten's Francesca, and not solely because Batten is bringing to bear the same sort of idealisation he practises with important male figures. There is also an implication, fully justified by Dante's text, that Beatrice and Francesca are not far apart as beautiful objects of desire. The most elevated love could easily have become illicit sensual passion, had it not been for heaven's intervention.

Some figures and events appear more than once in different lights. Most striking from this point of view are the concluding images. From the first intimations of the presence of the giants onwards, signalled by the blast from Nembrot's horn (no. 38), Batten establishes a forward movement that reaches its climax with the sight of a highly grotesque Satan (no. 42) and then the view of Hell from his perspective (no. 43) (which appears somewhat nonsensically before no. 42 in the Musgrave translation). Then comes the half-comic anticlimax of the sight of his inverted legs and feet (no. 44), and finally the emergence of Dante and Virgil to see the stars on the other side of the globe (no. 45). It could be argued that in the text the movement is more complex and does not have perhaps quite that form or tone. In particular, Dante (as everybody knows who has made the comparison with Milton) offers a deflated Satan, one who cannot speak and

[8] In the illustrated Musgrave, it appears as the frontispiece, though the story of Beatrice taking pity on Dante is only recounted by Virgil to Dante in Canto 2. I have followed Dante's order rather than Musgrave's.

simply continues his doleful chewing of the souls of Judas, Brutus and Cassius in a purely mechanical way, an emperor who remains terrifying but is not imperial at all. But Batten, however close he stays to the text, is also an interpreter of what Dante is doing, and his interpretation of the concluding canti is certainly one to be considered seriously, as are the implications of all his illustrations.

Batten does not aim to impose a powerful personal vision in the manner of Blake and many more modern illustrators (Salvador Dalì, Tom Phillips, Robert Rauschenberg, among others), but he nonetheless offers a particular way (or ways) of looking at Dante's Hell. If illustration is expected to help flagging readers (of which, in the case of Dante, there are always many) and to give them pleasures that have a bearing on the text but also have value in their own right, then Batten is outstanding. His publisher David Nutt was barely exaggerating when he wrote in the endnote to the 1900 exhibition catalogue, 'Mr Batten's designs speak for themselves, but the publisher may be allowed to emphasise the fact that they essay to interpret as well as to illustrate, and that they thus form a valuable addition to the exegesis of the *Inferno*, as well as an artistic achievement of the first rank.'[9]

Nutt was right and those who ignored or dismissed Batten were, to say the least, blinkered. The sad thing is that the blinkeredness continued for so long. The 1965 verdict of Gilbert Cunningham, the excellent historian of Dante translations into English, was damning: 'The drawings are wood-engravings, of varying relevance and interest, more likely to be admired for some degree of technical skill than for any light they shed on the poem, though R. A. [Anning] Bell says that Batten's studious mind revelled in the preliminary labour of working out a thorough understanding of the complex geographical plan of the *Inferno*.' Even as late as 1994 Eugene Paul Nassar was similarly dismissive: 'Essentially decorative they rarely capture a complex Dantean tonality. The scenes of the *Inferno* are paraded, often with delightful line, but with little of Dante's inner life …'[10]

[9] See Note 2.

[10] See Cunningham, p. 191, and Eugene Paul Nassar, *Illustrations to Dante's Inferno* (Rutherford: Farleigh Dickinson University Press, 1994), p. 23.

* * *

A year after Batten's death, Mary Batten wrote a letter to the Principal of Lady Margaret Hall in which she said that 'it was great trial to my husband that these drawings, the work of three years, were hidden from the world for over thirty years' and that they were 'the culmination of my husband's work in book illustration.' The pain and disappointment are evident and understandable.[11]

It may well be that the combination of feeling that he could go no further as an illustrator and disappointment at the way the Dante drawings were not given the exposure and recognition they merited led Batten largely to abandon book illustration after 1900. Instead he turned his energies to recuperating Renaissance techniques of fresco and tempera painting, becoming secretary of the Society of Tempera painters. He carried out painting commissions for English churches, notably St Martin's Church, Kensal Rise, and Christ Church, Lichfield, as well as continuing a successful career as a painter in oils. He was also active in other ways, notably in the Art Workers Guild. In addition he published a book of poems, almost all centred on his paintings of the 1880s and 90s,[12] and, more curiously, a treatise on the possibility of human beings achieving winged flight.[13] Overall he was a highly talented and individual figure, whose work deserves serious re-evaluation, his Dante illustrations above all.[14]

[11] Mary Batten, Letter to the Principal, Lady Margaret Hall, 20th January 1933 (LMH, Domestic Papers Box 3, Musgrave Bequest).

[12] John D. Batten, *Poems* (London: Chiswick Press, 1916). This had been preceded by an earlier collection, *Verses* (Cambridge: Devana Press, 1893).

[13] John D. Batten, *An Approach to Winged Flight* (Brighton: The Dolphin Press, 1928).

[14] This Introduction develops from and supplements my 'John Dickson's Illustrations to the *Inferno*', in Guido Bonsaver, Brian Richardson and Giuseppe Stellardi (eds), *Cultural Reception, Translation and Transformation from Medieval to Modern Italy. Essays in Honour of Martin McLaughlin* (Oxford: Legenda, MHRA, 2017), pp. 239–56, which contains fuller bibliographical references than seemed appropriate here.

NOTE

The order of Batten's illustrations followed here is that of Dante's poem. The Musgrave translation departs from Dante at the beginning and end, and also excludes one drawing (no. 41). There are four sets of the drawings in Lady Margaret Hall Library. Eventually I put aside the not quite complete mounted set originally exhibited at Leighton House in 1900, since not all are in good condition and, in some cases, have highlighted corrections or adjustments. This was the set submitted to the engraver. The second set are believed to be printer's proofs returned to the artist for his approval. This set is complete apart from no. 41, but is plainly only of proof quality. Thirdly, there is an incomplete set of collotype reproductions on fine yellow-tinted paper, probably intended for exhibition at some point between 1912 and 1920. Fourthly, there is another set of collotype reproductions on stiff white card with a considerable number of duplicates. All the reproductions in this last set are clear and in good condition and are the ones chosen here, apart from the very first drawing for which we have only the proof copy.

The titles are purely functional aids for the reader. They differ in places from those in Batten's notes, which are clearly intended merely to help the engraver and printer. There are no titles in the Musgrave translation.

The passages of Dante translated are those which in most cases we know from his notes Batten himself had in mind. The translations are my own. They gesture towards Dante's *terza rima* but try mainly to be clear and functional. With some regret I put Musgrave's versions to one side as too old-fashioned and idiosyncratic to be acceptable to any modern reader, as I explain in the Introduction. The commentaries aim simply to clarify what is going on in the drawings in relation to Dante's poem and who the figures depicted are.

John Dickson Batten's Illustrations

1

DAWN AT THE START OF THE JOURNEY

On emerging from the dark wood of sin and ignorance Dante looks up and sees the sun rising. Batten shows the leafless trees of the wood with the sun shining through them and, on the right, the stars that Dante says were present at the creation of the world. These were usually considered to be the constellation of Aries, which appears with the sun in spring. Dante had mentioned the sunrise briefly near the start of the poem (ll.16–18). In the original the slightly fuller description, translated below, which Batten drew on for his opening image, comes immediately after the appearance of the leopard (no. 2).

> The time then was the very start of morning,
> And the sun was climbing upward with those stars
> That were there with him when God's divine love
>
> Set the first time those lovely things in motion.
> So I was given, I felt, grounds for good hope
> Regarding that beast with the gaudy skin
>
> Both by the hour of day and the sweet season.

<div align="right">(1.37–43)</div>

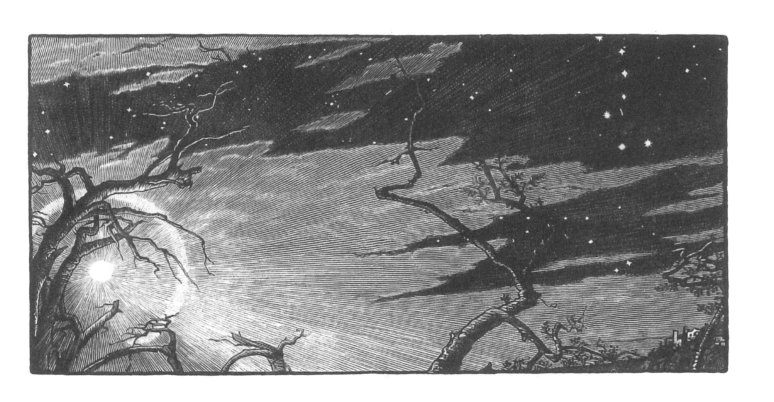

2

THE LEOPARD

Behind Dante is the dark wood of sin and ignorance from which he has just escaped. He tries to climb the hill of virtue and knowledge directly, but is confronted by a leopard, symbolising the sin of lust. In Batten's drawing he is gripping, for protection, the cord round his waist that Virgil will later throw as bait for Geryon (see no. 26). It may indicate that Dante was perhaps a lay member of the Franciscan order.

> After I'd briefly rested my tired body,
> I started off again over the empty slope,
> My lower foot always the steadier one.
>
> And look, just where the steeper part began,
> There came a lithe and very rapid leopard,
> Covered all over by a spotted pelt,
>
> And it would not move from in front of me,
> But interfered so strongly with my progress
> That more than once I turned round to go back.
>
> (1.28–36)

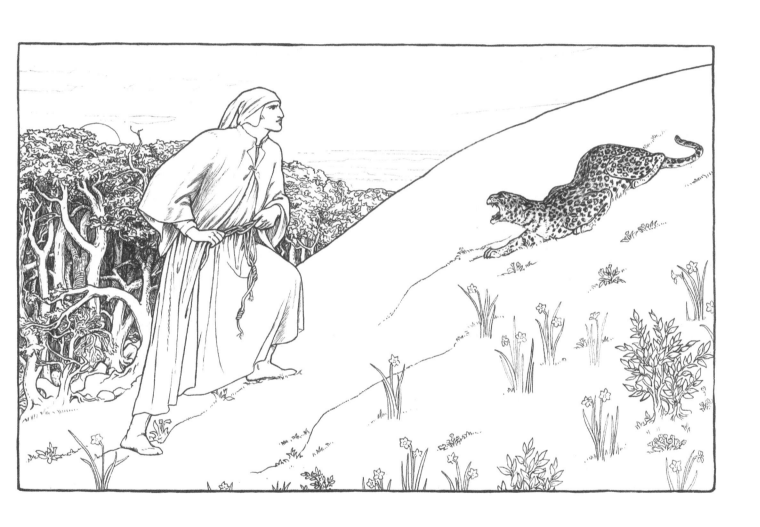

3

THE THREE BEASTS

The leopard is joined by a lion (pride) and a wolf (greed). This last is thin and hungry and more threatening than the other two beasts. It forces Dante back towards the dark wood. However, on the right Batten shows the spectral figure of the Roman poet Virgil emerging from the wood. The moment chosen is just before Dante addresses, for the very first time, the spirit who will help and guide him on his journey.

> And as one who has worked hard to make money,
> When a time comes that makes him lose it all,
> Finds all his thinking changed to tears and grief,
>
> So was I troubled by the unresting beast,
> That coming forward at me, bit by bit,
> Forced me back down to where the sun is silent.
>
> As I was falling back into the depths,
> My eyes were offered then the sight of one
> Whose voice long silence seemed to have made weak.
>
> (1.55–63)

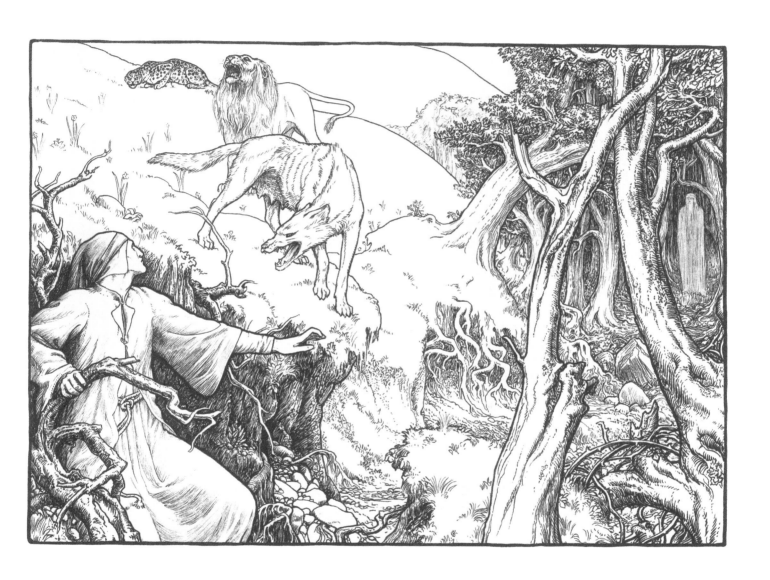

4

BEATRICE

Virgil explains to Dante how his beloved Beatrice (who had died some ten years before the time of the poem and is in Paradise) has seen his plight and visited Limbo (the abode of virtuous pagans and unbaptised souls) to ask Virgil to provide help. Batten shows her looking down pityingly at Dante struggling to climb the mountain. Behind her are the concerned figures of St Lucy, who has been sent to Beatrice by the Virgin Mary, and Rachel, Beatrice's companion in Paradise. St Lucy probably symbolises illuminating grace and Rachel the contemplative life.

'The one who is my friend, but not of fortune,
Is so impeded on the barren slope
From going on that fear has driven him back.

I am afraid he is so lost already
That I have risen too late to bring him help,
To judge from what I've heard in heaven about him.

Now stir yourself and, with your decorous words
And all else necessary to rescue him,
Help him so that you bring relief to me.

I am Beatrice who sends you journeying.
I come from where I desire to return.
Love made me move and it now makes me speak.'

(2.62–72)

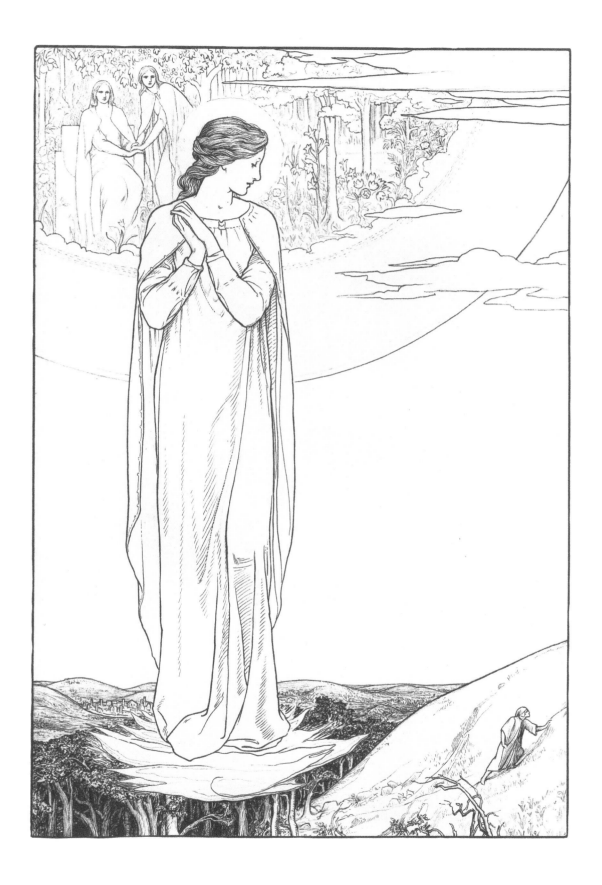

5

THE DOORWAY TO HELL

Batten shows a resolute Virgil taking the hand of an understandably nervous Dante to lead him through the doorway. Odd bits and pieces of timber at the entrance itself suggest the patched-up character of Hell as a whole, in spite of the complex order of its circles. The first words are just visible of the last three lines of the inscription over the doorway with which Canto 3 opens.

'Through me you pass into the dolorous city,
Through me you pass into eternal pain,
Through me you pass to be among the lost.

Justice it was that moved my lofty maker.
And I was made by the divine power,
The highest wisdom and the primal love.

Before me there were no created things
But things eternal, and I eternal am.
Abandon all hope you who enter here.'

(3.1–9)

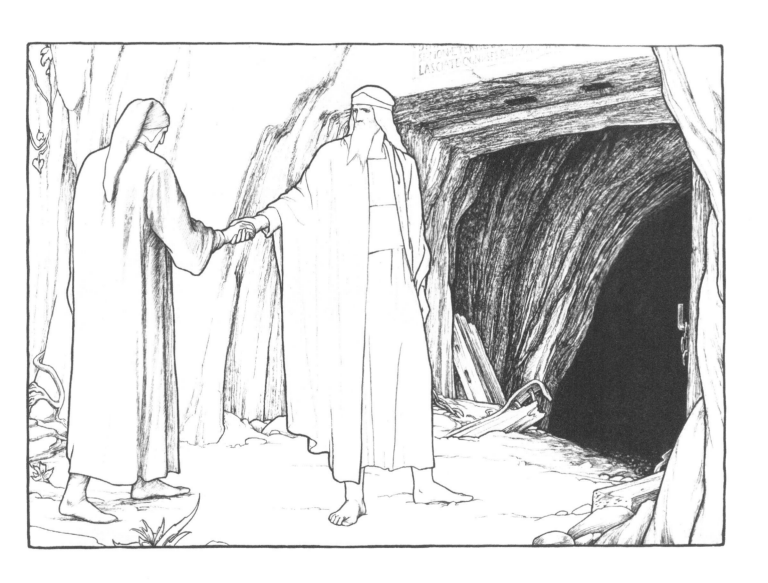

6

THE VESTIBULE

Dante and Virgil have behind them the light of day and, before them, the vestibule of Hell in which they can make out the crowds of countless nameless souls who, as Virgil explains, refused to make any choice between good and evil. They are punished by having to run ceaselessly and chaotically through the darkness, bitten for ever by hornets and wasps. Mixed among them are the souls of the angels who similarly refused to choose between God and Satan. Dante notes particularly an immense rabble chasing after a meaningless banner.

'These have not any hope of meeting death,
And their unseeing life is such a low one
That they are envious of any other lot.

The world lets no report of them survive.
Pity and justice both hold them in scorn.
Let us not speak of them, but look and leave.'

And when I looked again I saw a banner
That waved around and rushed so quickly on
I thought that any rest was quite beyond it.

And there behind it came so long a troop
Of people that I would not have believed
That death could ever have undone so many.

(3.46–58)

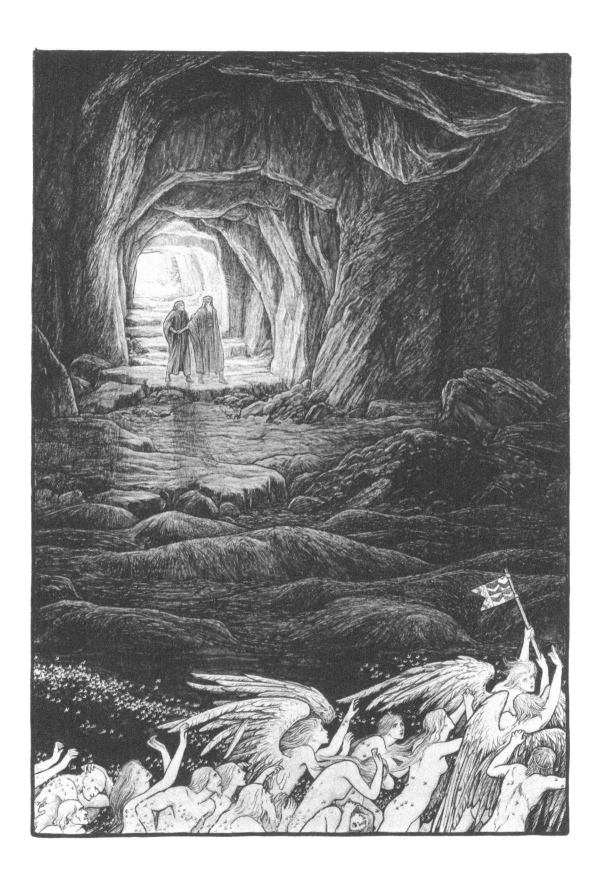

7

CHARON

Dante and Virgil now have the anonymous hordes of souls they
have just seen behind them. They have reached the bank of the
Acheron, the first of the infernal rivers, together with some of the
damned souls (on the left of the picture) on the way to their place
of punishment, who are waiting to be ferried across by Charon,
a hairy figure with flame-ringed eyes. As he approaches, Charon
shouts to Dante that he cannot take him since he is still alive,
but is put in his place by Virgil, who says that Dante's journey is
divinely authorised.

> And my leader told him, 'Charon, stop raging.
> This is a thing willed there where there is power
> To do what the will is, so ask no further.'

> At this the shaggy cheeks stopped being shaken
> By the boatman of the grey gruesome marsh,
> Whose eyes were circled round by wheels of flame.

> (3.94–9)

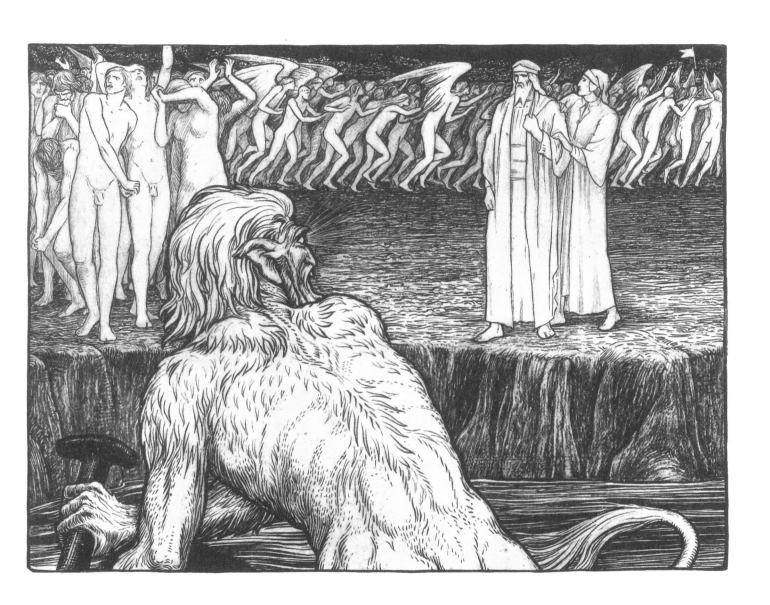

8

LIMBO

Dante and Virgil (in the middle of the picture) are entering Limbo, the first circle of Hell proper. It is a place of a certain brightness, a place not of punishment as such, but of unfulfilled desire and 'suffering without torment'. In it are confined otherwise sinless souls who never knew Christ. The crowds that Virgil and Dante first see comprise unbaptised children and adults of both sexes. They will go on to see ancient poets, philosophers, heroes and heroines, and some Muslim rulers and thinkers. Behind them is a luminous castle with seven walls, which Dante and Virgil will soon enter.

> In this place, as we learned through listening,
> There was no weeping ever, only sighs
> Which caused a trembling in the eternal breeze.
>
> The cause was suffering without torment
> Borne by the crowds, that were so large and many,
> Composed of infants, women and grown men.

(4.25–30)

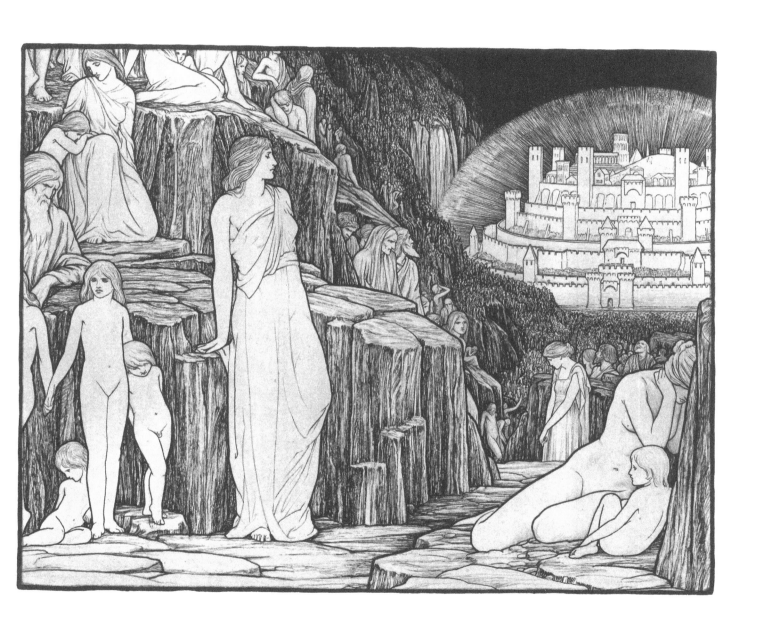

9

DANTE AND THE POETS

Dante is shown in the midst of the 'beautiful school', composed
of the five greatest poets of antiquity, to which they have just
admitted him. Homer is judged the greatest of all, though Dante
had never read him, and leads the way, his sword signifying that
he is the supreme poet of war. He is followed by Virgil and then
Dante. Behind Dante come Horace, Ovid and Lucan, assuming
Batten is following Dante's order, with Horace and Lucan looking
surprisingly youthful and Ovid (the poet of the *Metamorphoses*
rather than the love poet) looking grave and austere. The group
converse together as they approach the entrance to the shining
castle. All are barefoot, apart from Dante, the one living being
among them.

> And so I saw the beautiful school assemble
> Of that lord of the highest kind of song
> Who soars above the others like an eagle.
>
> When they had talked together for a while,
> They turned towards me with a sign of welcome,
> And seeing such a thing my master smiled.
>
> And then they paid me yet a greater honour,
> For they admitted me into their ranks,
> Making me sixth in that array of wisdom.
>
> So we went on until we reached the light,
> Speaking of things it's best now to omit,
> Which it was good to speak of in that place.

(4.94–105)

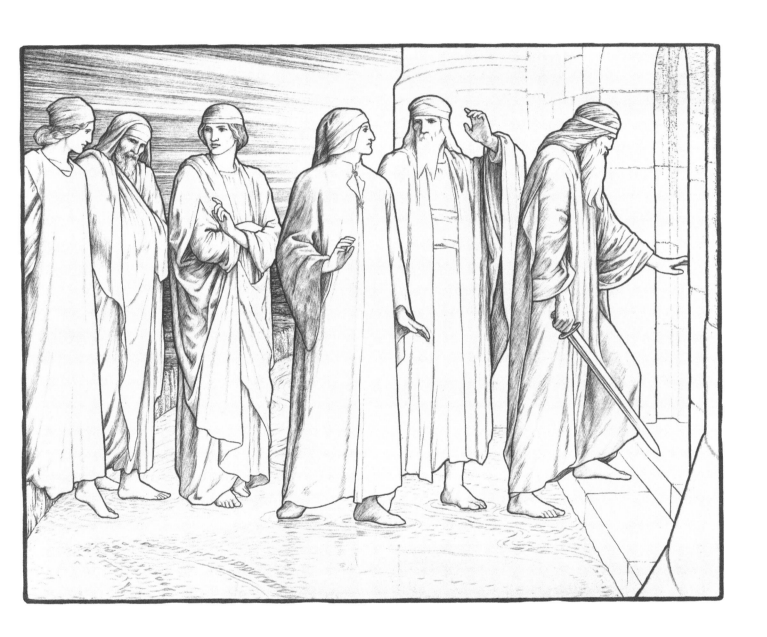

10

MINOS

The ancient Minos, king of Crete, who becomes a judge of the dead in Virgil's *Aeneid*, is now a monstrous figure. The souls come before him to learn which part of Hell they are condemned to. He tells them which circle it is by winding his tail round his body the appropriate number of times. Batten shows one such soul asking for clarification. In the background are the souls of the lustful being carried along by the dark wind whom Dante will see immediately on leaving Minos.

> Minos is horrifyingly there, and snarling.
> He assesses sins at the very entrance.
> He judges and sends on by twining round.
>
> I mean that when the ill-begotten soul
> Comes there before him, it confesses all,
> And that perceptive expert in all sins,
>
> Decides what part of Hell is suitable,
> He winds his tail round him as many times
> As are the levels he wants it sent down.

(5.4–12)

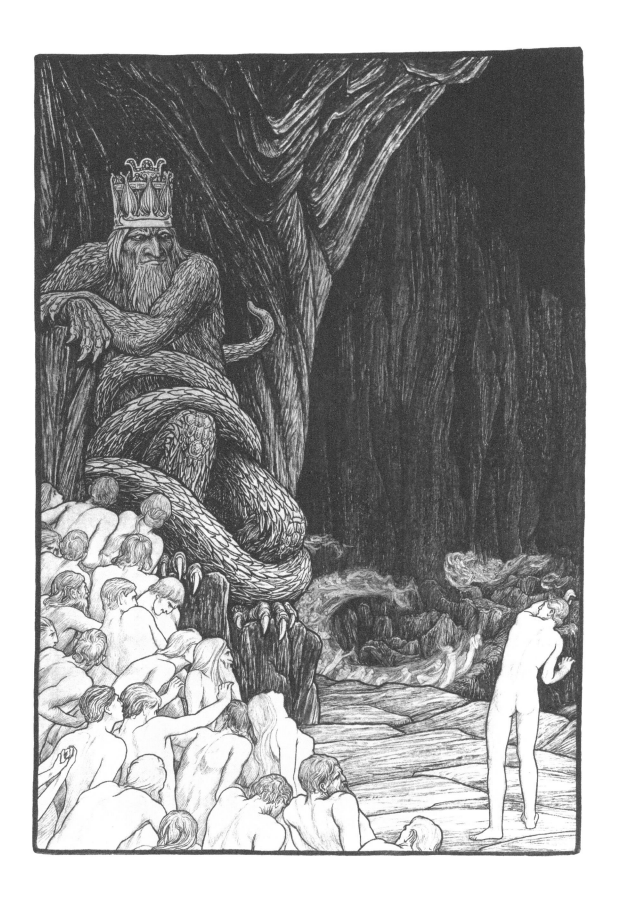

11

THE LUSTFUL

The Second Circle is the first containing actual torments. In it are the souls of sinners who have surrendered to lust. They are buffeted along and up and down by a roaring black storm. Dante identifies various souls, and asks if he can speak with two whom he recognises. Virgil gives permission, Dante calls out, and the two souls emerge from the throng (which includes Virgil's Dido, among others) and come over towards Dante and Virgil.

As soon as the wind turned them towards us,
I called out to them. 'O you troubled souls,
Come speak with us, unless some power forbids it.'

Like doves, who answer the call of desire,
And through the air with open, steady wings
Fly to their sweet nest carried by their will,

So they left the long line containing Dido,
And came towards us through the baleful air,
Such force was there in my emotional cry.

(5.79–87)

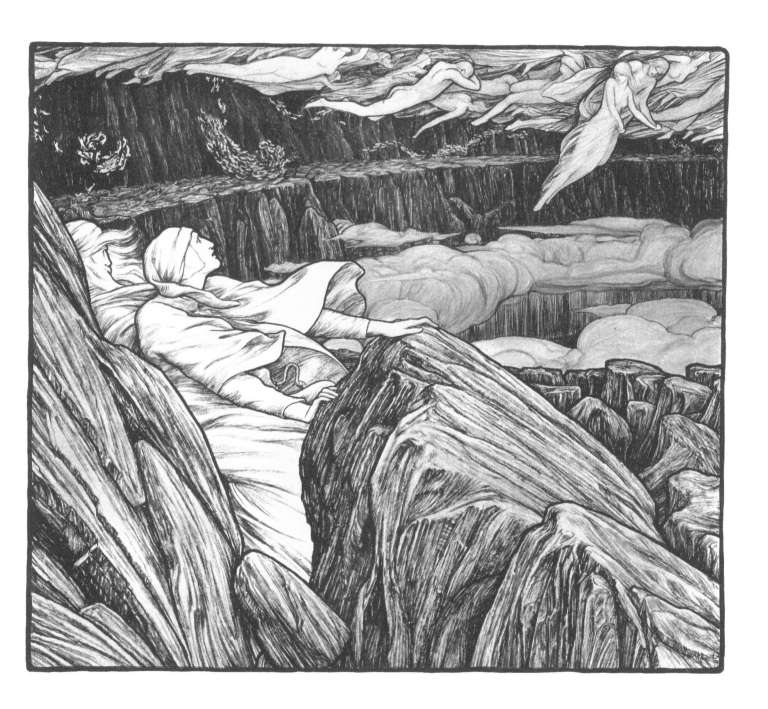

12

PAOLO AND FRANCESCA

The two souls Dante wishes to speak with are Francesca da Rimini and her brother-in-law, Paolo Malatesta from Ravenna, who were treacherously killed by Francesca's husband, Gianciotto, when he discovered their affair. He now will meet due punishment (Francesca tells Dante) in Caïna, the part of the bottom-most circle of Hell where traitors to their families are punished. Dante says that they seem especially light on the wind (l.75), and Batten captures some of that lightness in his romantic image of them almost dancing over, though the swirling veil is his invention. It is easy to imagine his Francesca voicing some of the most famous lines on love in the whole poem.

> 'Love, which takes quick hold in the noble heart,
> Seized hold of this man for the lovely form
> Taken from me, and how taken hurts me still.
>
> Love, which lets no one loved not love in turn,
> Seized me so strongly for his loveliness
> That, as you see, it does not leave me yet.
>
> Love led us to a single death together.
> Caïna waits for him who took our lives.'
> These were the words proffered to us by them.

<div align="right">(5.100–108)</div>

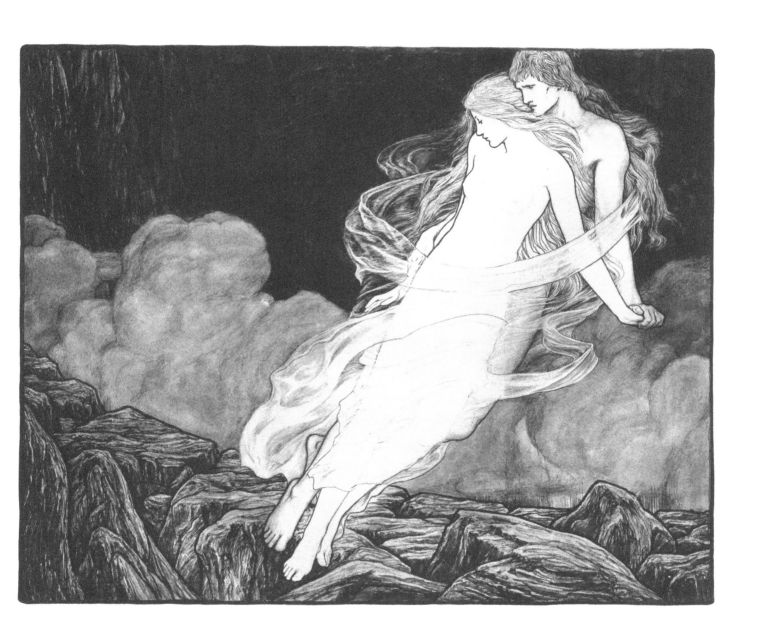

13

CERBERUS

Cerberus is the massive, three-headed, dog-like demon who presides over the Third Circle, that of the gluttons, who are plunged in stinking black mud under freezing hail and rain, howling with pain as they are torn by Cerberus's claws. He reacts with fury at the sight of the visitors. Batten shows Dante protecting his ears against the din as Virgil picks up a large handful of mud to throw into the beast's jaws, which will placate him enough to let them go on.

When Cerberus, the great filthy beast, perceived us,
He opened up his mouths and showed his fangs.
Not one limb did he have that he kept still.

My leader then extended both his arms,
Picked up some earth, and, clenching his fists full,
Hurled it straight into the ravenous throats.

Just as a dog that's barking hungrily
Quietens itself on biting into food,
Straining and struggling only now to eat,

In the same way those filthy muzzles calmed
Of Cerberus the demon, whose thundering
So hurts the souls they wish that they were deaf.

(6.22–33)

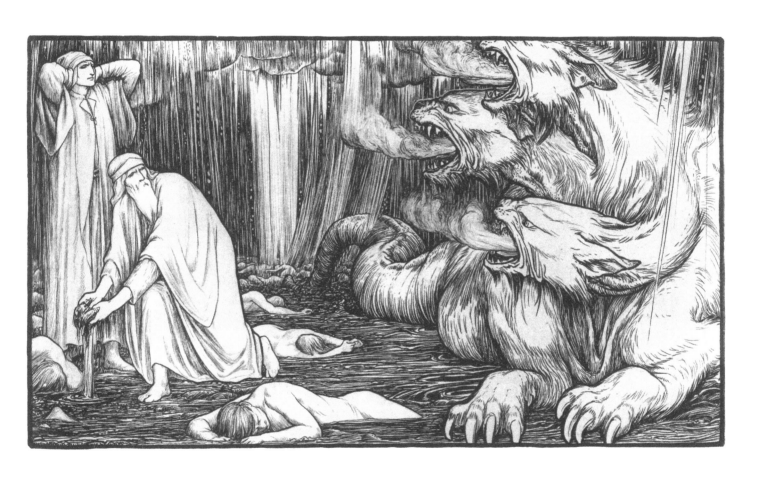

45

14

PLUTO

Pluto is the guardian of the Fourth Circle, which contains souls guilty of either avarice (amassing and hoarding money) or prodigality (spending money recklessly). Batten shows him as a bestial figure (Dante's Virgil calls him a wolf), crouched at the edge of the previous circle (that of the gluttons), at the top of the steps leading down to the circle itself, where a mass of sinners can be seen undergoing their punishment (see no. 15). Pluto is turned towards Dante and Virgil (who are not shown) and is shouting at them. His words, which open Canto 7, are a distorted but not entirely nonsensical scream to his master, Satan: in the original, 'Papé Satàn, papé Satàn aleppe'.

> 'Oy Satan, oy Satan, look see this here,'
> So started Pluto screeching stridently.
> And that noble sage, who understood it all,
>
> Said to comfort me, 'Do not let your fear
> Unsettle you. Whatever power he has,
> He will not stop us going down this cliff.'
>
> And then he turned round to that bloated face,
> And said to it, 'Be quiet, cursèd wolf,
> Consume yourself and all your rage within.'

(7.1–9)

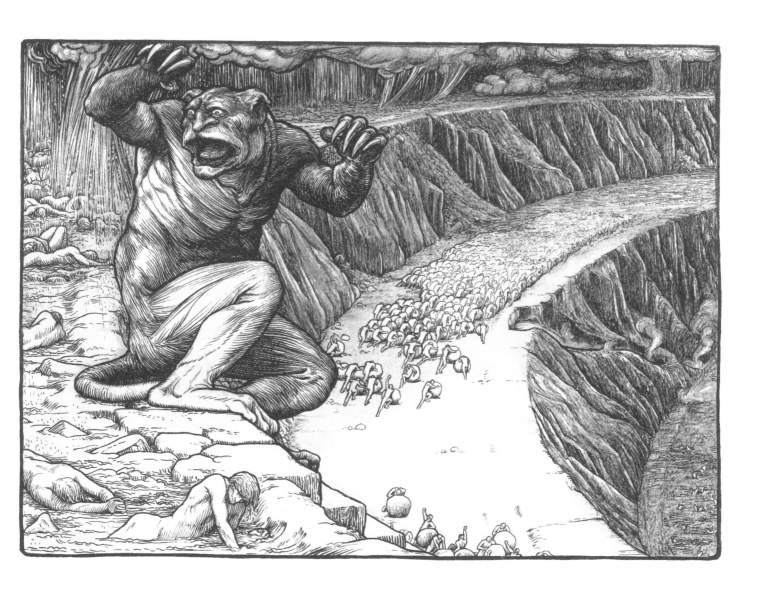

15

THE AVARICIOUS AND PRODIGALS

The sinners in the Fourth Circle are punished by having to push enormous boulders round the perimeter, the avaricious in one direction, the prodigals in the other. When they meet, they bang against each other and shout out reproaches to the opposite set for what they have done, and then start back in the opposite direction until they meet again. Dante emphasises the mass of clerics among the avaricious, and Batten depicts several tonsured heads. Virgil and Dante are shown in the background coming down the stairway from the previous circle.

> Here I saw far more people than elsewhere,
> On one side and the other, loudly shouting,
> Making great weights roll forward with their chests.
>
> They banged into each other, then at once
> They all turned round, and started to push back,
> Crying, 'Why do you hoard?' and 'Why do you squander?'
>
> So they went back around the dismal circle,
> In both directions to the opposite point,
> Shouting their shaming slogan once again.
>
> Then each turned round, having reached that spot,
> Through his half-circle to the previous joust.

(7.25–35)

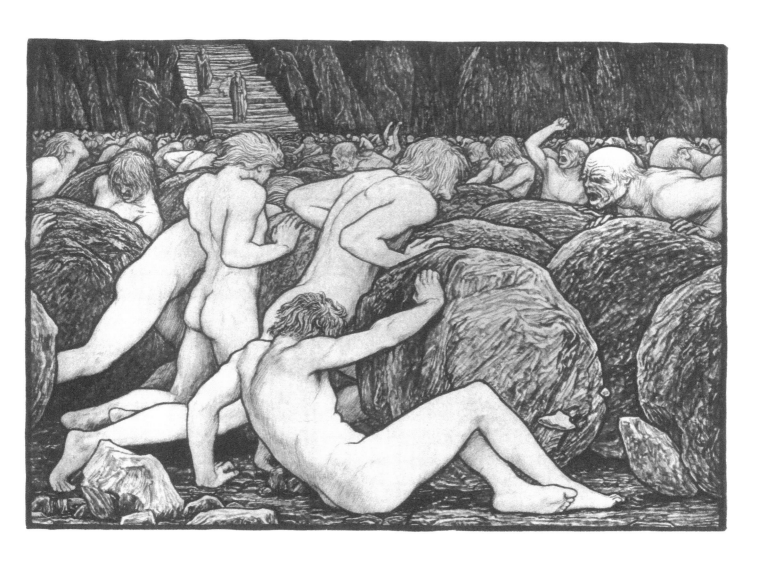

16

THE STYX

The River Styx occupies the Fifth Circle. In it are plunged the souls guilty of all-consuming anger, now fighting indiscriminately and insulting each other. Virgil and Dante are shown waiting at the edge for Phlegyas, the demonic ferryman, who will, very unwillingly, take them across. They are waiting by a tall tower which Dante says flashes a fiery signal to the City of Dis on the other side. Behind the city's dark walls are mosque-like buildings illuminated by infernal fire.

A bowstring's never let an arrow fly
That sped so quickly through the air,
As I saw speed a tiny little boat

Over the water to us at that moment,
Under the steering of a single sailor,
Who shouted, 'Now you've arrived, you wicked soul!'

'Phlegyas, Phlegyas, you shout out emptily,'
My lord replied, 'at any rate, this time.
You'll have us just to take across the mud.'

(8.13–21)

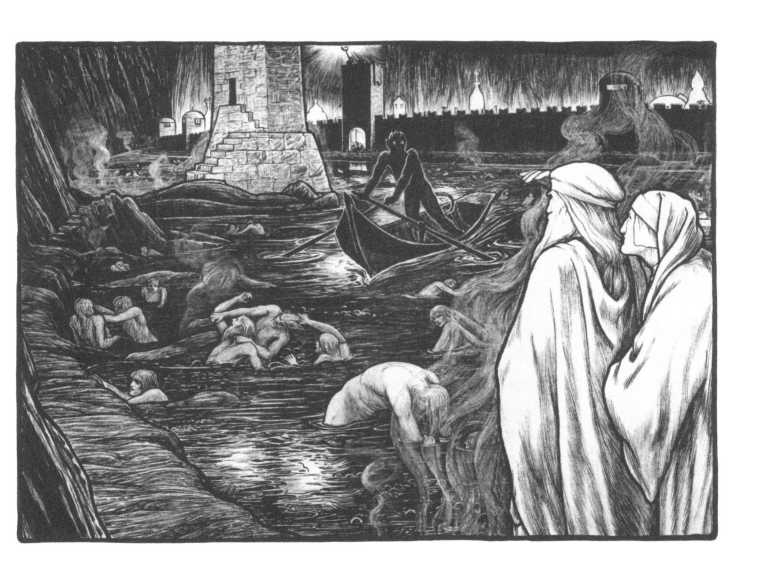

17

DEVILS AT THE GATES OF DIS

A mass of devils had appeared from the City of Dis and agreed to speak with Virgil. Batten shows them pouring back inside, after Virgil has failed to persuade them to let them proceed. On the left can be seen the claws of one pulling the iron gates to, with the flames of the city blazing behind. In the upper right corner is the tower on the other side of the Styx, which here is still flashing its sign. Dante does not describe the devils; their fantastical animal forms come from Batten's own imagination.

> I could not hear what Virgil said to them.
> But he'd been there with them for just a moment
> When all rushed helter-skelter back inside.
>
> Those adversaries of ours closed the gates
> In the breast of my lord, who was shut out,
> And turned round to rejoin me with slow steps.

(8.112–17)

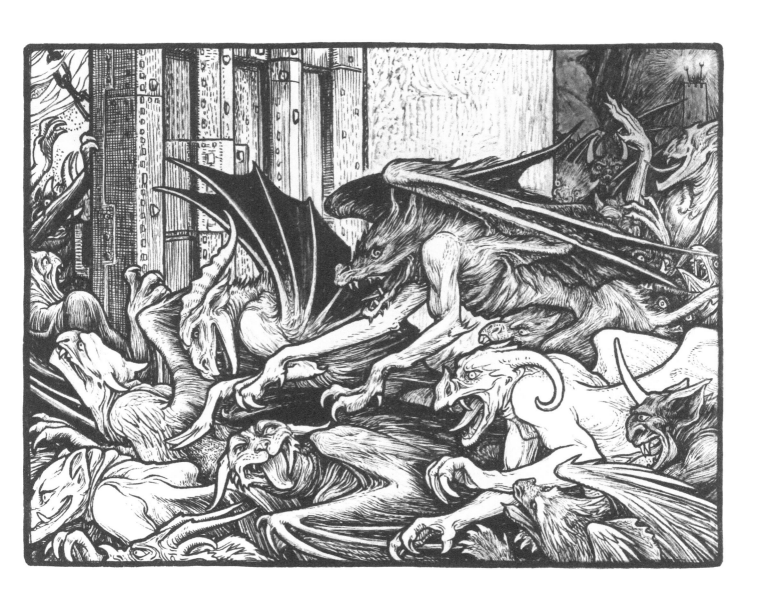

18

THE HEAVENLY MESSENGER

A heavenly messenger has been sent to open the gates of the City of Dis, which have been closed against Dante and Virgil. He will simply tap on the gates with the stick he is carrying and they will open. Batten's messenger is a warrior angel who dominates the foreground, where souls in the Fourth Circle can be seen pushing their boulders (see no. 15) and below them, the Styx with the souls plunged in its mud (see no. 16). Below him by the gates are a minuscule Dante and Virgil looking upwards, while the devils leap about in disarray on the walls. Within the walls are outlined the tombs of the heretics in the Sixth Circle, the mountainous rocks stretching down to the Seventh Circle and the precipitous drop to the Eighth, to which Dante and Virgil will descend on the back of Geryon (see no. 27).

> As frogs before the hostile water-snake
> All run off scattering across the water
> Until each finds some ground to burrow in,
>
> So I saw more than one thousand damned souls
> Likewise take flight before one who came stepping
> Steadily over the Styx with dry feet.
>
> He swept away that thick air from his face,
> With a repeated wave of his left hand,
> And that seemed the one thing to trouble him.
>
> I knew at once that he was sent by heaven,
> And turned round to my master, who just signalled
> I should stay calm and bow my head to him.
>
> (9.76–87)

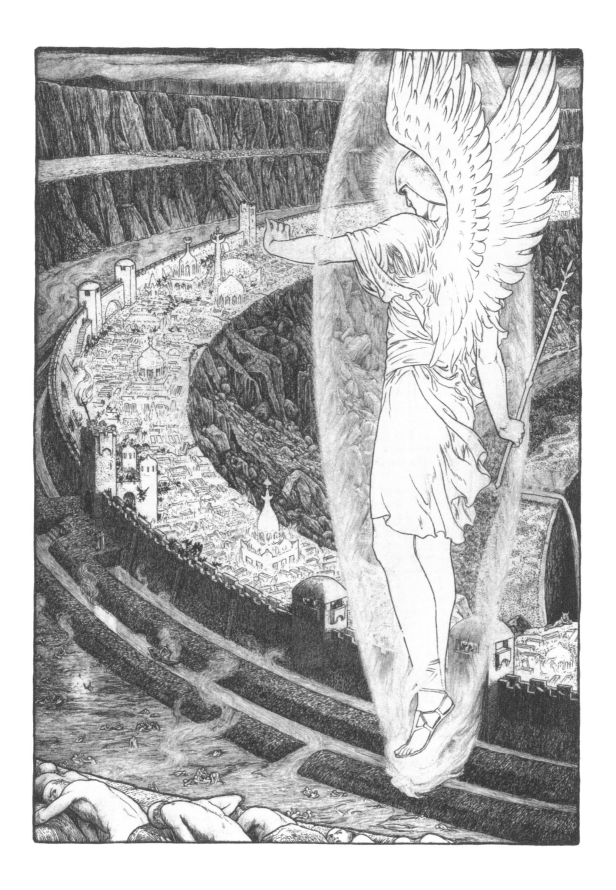

19

FARINATA

Dante and Virgil are now walking along a narrow passageway immediately inside the City of Dis. On one side are the walls, on the other, the open blazing tombs of the Sixth Circle containing the souls of heretics, meaning primarily here those who did not believe in the immortality of the soul. Much of the canto is taken up by a political exchange between Dante (whose family was Guelph) and the Florentine Ghibelline leader, Farinata degli Uberti. Batten captures some of his character in the original by representing him as a noble and determined looking military figure. The image shows the moment just after he has disconcertingly broken in on Dante and Virgil's conversation. Virgil now tells Dante to get himself together and look at the famous soul who has spoken.

> 'O Tuscan who through the city of fire
> Walk on alive, speaking so honourably,
> Be pleased to stop a short while in this place.
>
> Your form of speech shows plainly that you are
> A native of that noble fatherland
> To which I proved perhaps too damaging.'
>
> Suddenly the sound of these words came
> From one of the tombs, at which I drew myself
> In fear a little closer to my leader.
>
> He said to me, 'Turn round. What are you doing?
> See Farinata there, who's raised himself.
> You'll see the whole of him from the belt up.'

(10.22–33)

20

THE MINOTAUR

Dante and Virgil have stopped briefly so that Dante can become used to the stench coming from the lower regions. They are shown in this image as two small figures seated by one of the burning tombs of the Sixth Circle. In the original (Canto 11) Virgil is explaining to Dante the overall structure of Hell at this point. They will shortly go on to make the perilously steep descent into the Seventh Circle. Before doing so, they meet the figure that Batten makes his main focus here – the Minotaur, the monstrous result of the union between Queen Pasiphae, wife of King Minos of Crete, and the bull to whom she offered herself from inside a wooden cow. He is initially a broodingly still figure, as in Batten's image, though he at once explodes into self-destructive bestial rage. Below him can be just made out the three divisions of the Seventh Circle – the violent against others plunged in boiling blood, the violent against themselves now become arid trees, and the violent against God running over burning sand. The tiny figures on the nearside at the foot of the cliff are the centaurs who are the guardians of this circle.

> Against the tip of the smashed valley-side
> The infamy of Crete was lying stretched,
>
> The one that was conceived in the false cow.
> And when he saw us, he bit at himself,
> Like one who's ravaged by his rage within.

> (12.11–15)

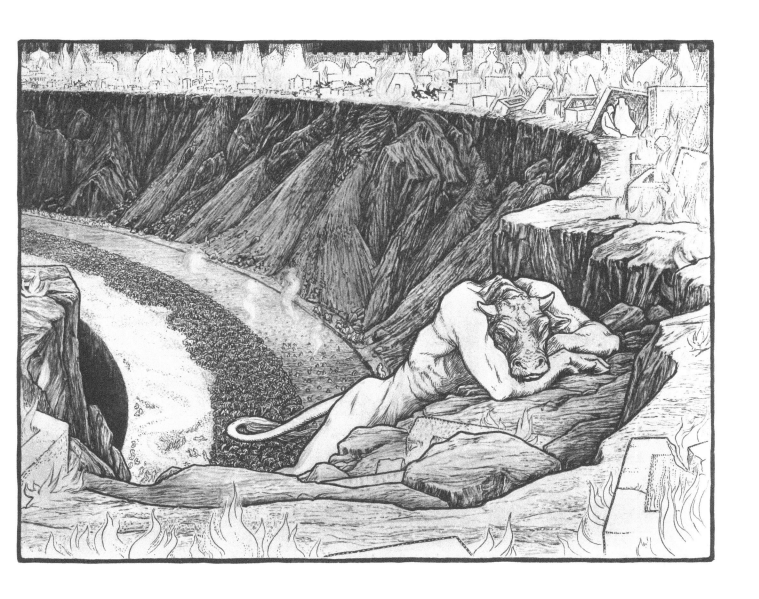

21

THE CENTAURS

As they finish their perilous descent, Dante and Virgil are accosted by three of the centaurs, with the bows and arrows they use to keep in order the sinners guilty of violent robbery and murder who are punished in this first part of the Seventh Circle by being plunged in a river of boiling blood (visible behind the centaurs in Batten's image). Virgil is shown addressing their leader, Chiron, who appears between two others named by Dante as Nessus and Pholus. He is explaining to his three initially threatening listeners that Beatrice descended from Paradise to give him the special task of escorting Dante, still a living man, on anything but a pleasure-trip through Hell, and that neither of them is guilty of robbery.

> And my good master, standing now by his breast,
> Where animal and human natures meet,
>
> Replied, 'He is alive, and just to him
> I am obliged to show the vale of darkness.
> Necessity propels us, and not pleasure.
>
> One came away from singing alleluia
> And gave me this exceptional commission.
> He is no thief, nor I a thieving soul.'

(12.83–90)

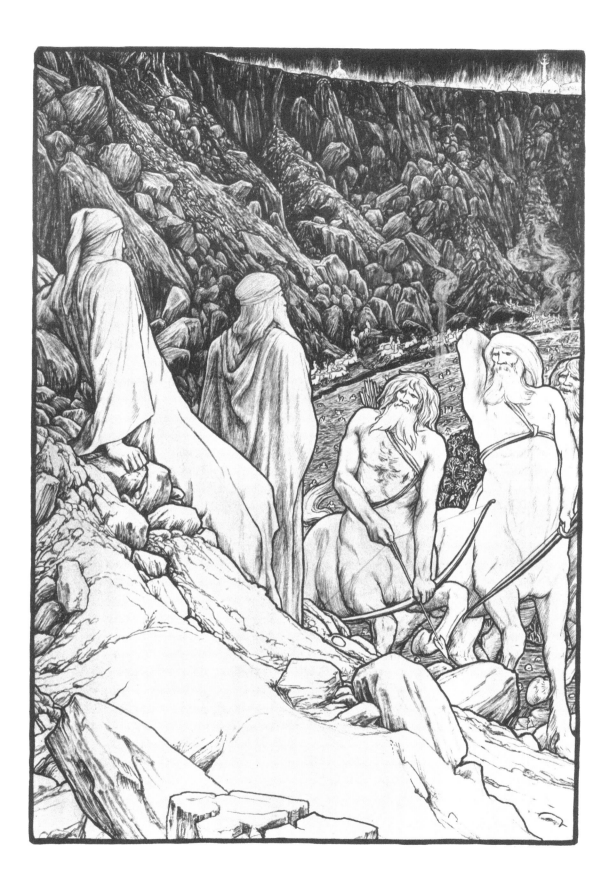

22

DANTE ON THE BACK OF NESSUS

At Virgil's instigation, Chiron has ordered Nessus to carry Dante along and then across the river of blood. Batten shows them as they make the crossing. Nessus is turning round to give explanations to a nervous-looking Dante, and behind them can be seen some of the slightly less horribly violent, who have boiling blood only up to their ankles. On the left is the figure of Virgil who, as a spirit, does not need transport, with behind and above him the two other centaurs they have just left (see no. 21). On the right is the wood of the suicides they are about to enter.

> So little by little the level dropped
> Of that blood, till it only boiled the feet.
> And there we made our crossing of the ditch.
>
> 'Just as, looking on this side, you see that
> The boiling blood becomes more and more shallow,'
> The centaur said, 'I want you to believe
>
> That on the other its depth more and more
> Keeps on increasing, till the part is reached
> Where tyranny is rightly made to groan.'

<div align="right">(12.124–32)</div>

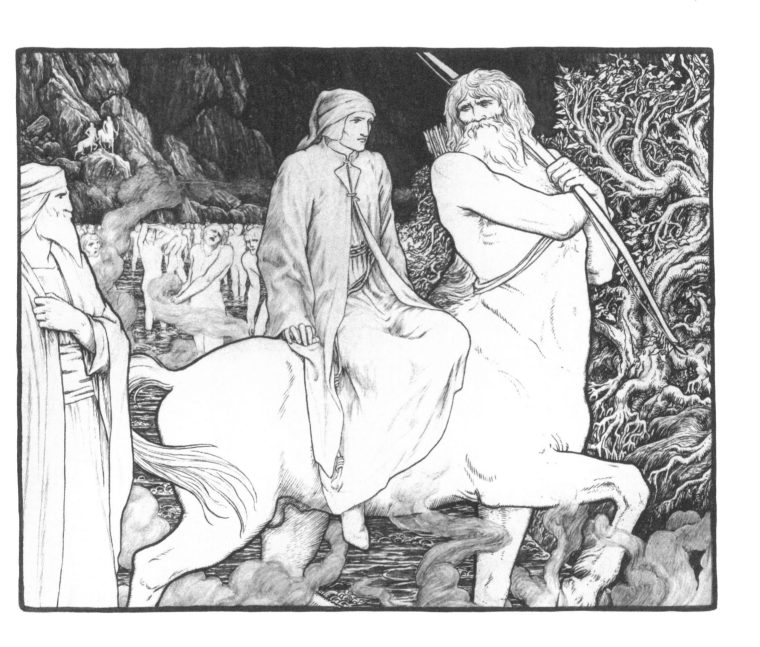

23

THE WOOD OF THE SUICIDES

The suicides are transformed into discoloured, twisted trees, the leaves of which provide food for Harpies, two of which are shown on the upper right with their women's faces and gross bird-like bodies. Dante hears wailing but can see no one. Batten has chosen the moment when, to show him that the suicides are actually present, Virgil has had him break off a branch on one of the trees and the soul (that of the courtier Pier della Vigna) begins to speak painfully with Dante through the blood dripping from its torn stump. The soul being chased by black hounds in the upper left corner is one of the self-destructive squanderers whose punishment is to be hunted through the forest, tearing at and being torn by the branches as they go.

> I think Virgil thought that I was thinking
> That all the voices heard among those bushes
> Issued from people who were hiding from us.
>
> And so my master said, 'If you break off
> A twig or two of just one of these trees,
> The queries you have will all also be cut short.'
>
> So then I stretched my hand forward a little
> And broke a small branch from a massive thornbush,
> At which the trunk called out, 'Why do you tear me?'

> (13.25–33)

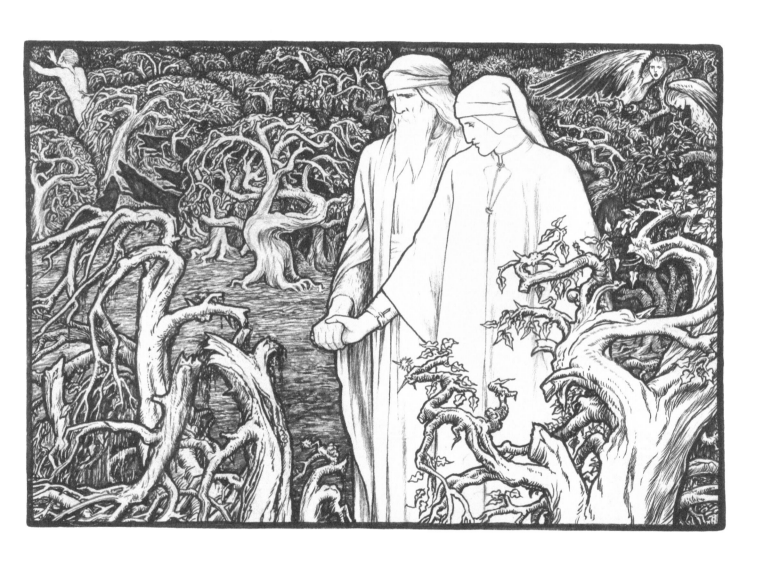

24

PHLEGETHON

On the right of the picture is the wood of the suicides and one of the Harpies. Dante and Virgil are now going on to the third section of the Seventh Circle, where the violent against God and nature are plunged beneath the unremitting rain of fire filling the background here. Batten shows Virgil telling a nervous-looking Dante to get up onto a stone dyke on which they will be able to cross this section unscathed. The dyke is one of two channelling Phlegethon, the river of boiling blood. Steam from it is visible on the left. It has the remarkable quality of extinguishing the flames pouring down from above.

> The riverbed and both its sloping sides
> Were made of stone, as also were its edges,
> So I deduced that was the way across.
>
> 'Of all the things that I have so far shown you,
> Since we first made our entry through the door
> Whose threshold is not barred to anyone,
>
> Nothing that's been presented to your eyes
> Is as remarkable as this present stream,
> Which kills all flames that blaze above it.'
>
> These were the words my master said to me.

(14.82–91)

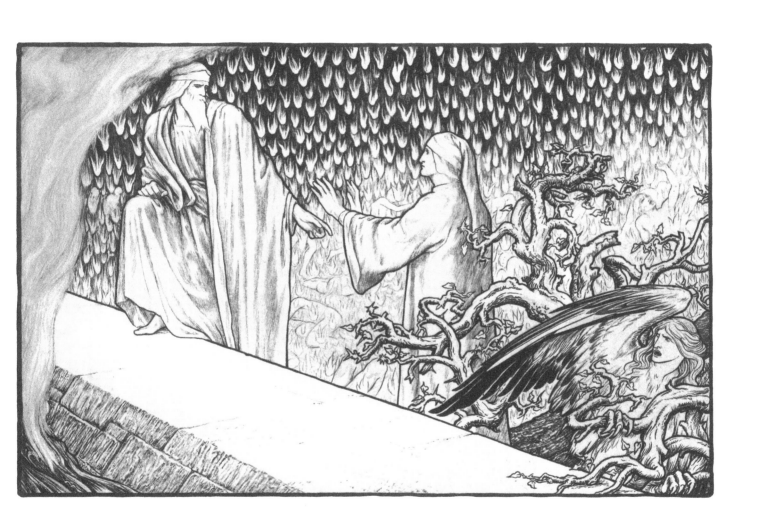

25

Brunetto Latini

Brunetto Latini was a writer and Dante's teacher in Florence. He is punished as a sinner against nature – that is, presumably, homosexuality – and has to keeping running at speed with other similar sinners under the rain of fire. Batten shows the moment after Brunetto has accosted Dante, who recognises him and is deeply distressed to find him here. Brunetto turns back to go along with Dante for a little while, though he has to keep moving. Dante demonstrates respect and affection throughout the conversation that follows, with, it seems, the approval of Virgil, who is shown reflecting seriously on what he hears. The image shows the scene from in front of the three figures. Hence steam from Phlegethon is now rising on the right.

> Eyed up and down like this by such a band,
> I was recognised by one, who caught hold
> Of my gown's hem and shouted, 'What a marvel!'
>
> And I, when he stretched out his arm towards me,
> Fastened my eyes upon his roasted features
> So firmly that his burnt face did not stop
>
> My mind from recognising who he was.
> And, lowering my own face down to his,
> I answered, 'Are you here then, Ser Brunetto?'
>
> And he: 'My son, do not resent it if
> Brunetto Latini comes back with you
> A little way and lets the troop go on.'

(15.22–33)

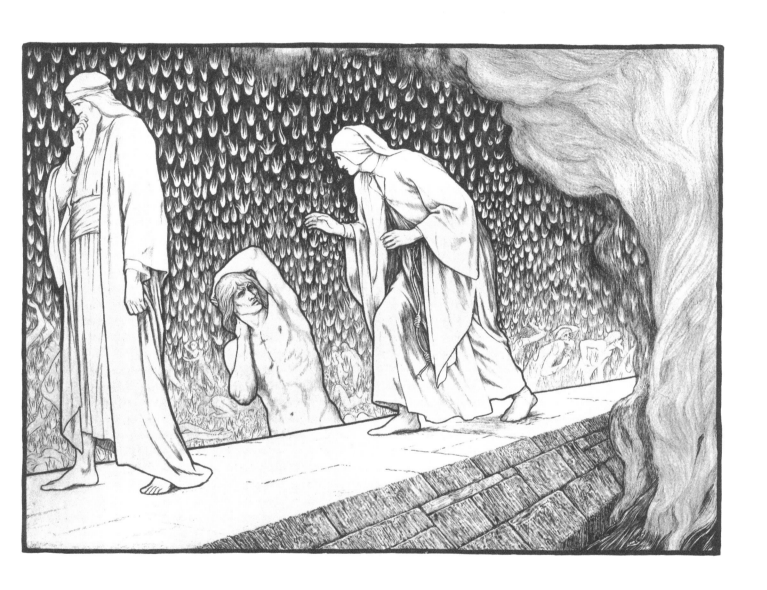

26

THE USURERS

Dante and Virgil are at the end of the river-channel, having now traversed the whole of the Seventh Circle. Batten shows in the distance the wood of the suicides and behind it the violent in the boiling blood with the centaurs guarding them. Nearer at hand are the violent against nature running over the burning sand under the rain of fire. The steaming Phlegethon is pouring out of the mouth of its channel in the foreground over the cliff (which we cannot see here) above the Eighth Circle. The viewer is positioned in space above the cliff, and sees Dante and Virgil just after Virgil has thrown a cord that Dante was wearing round his waist over the cliff's edge. The cord is an obscurely symbolic one, which Dante says he had hoped would help him deal with the leopard that appeared at the start of the poem, though Batten makes it curiously snakelike. In any event, it acts as a summons to Geryon (see no. 27). On the left Batten places three sinners guilty of usury, which is also classed as a sin against nature. Their penalty is to sit (rather than run) on the burning sand. Dante does not name them, but describes the money-pouches with family emblems on them (a lion, a goose and a sow) that Batten shows them wearing.

> I had a cord I'd tied around my waist,
> And thought once that with it I might
> Capture the leopard with the coloured hide.
>
> After I had completely loosened it,
> As my leader commanded me to do,
> I passed it to him rolled up in a bundle.
>
> Then he turned round towards the right-hand side,
> And out some distance from the edge
> He threw it down into that deep ravine.

(16.106–14)

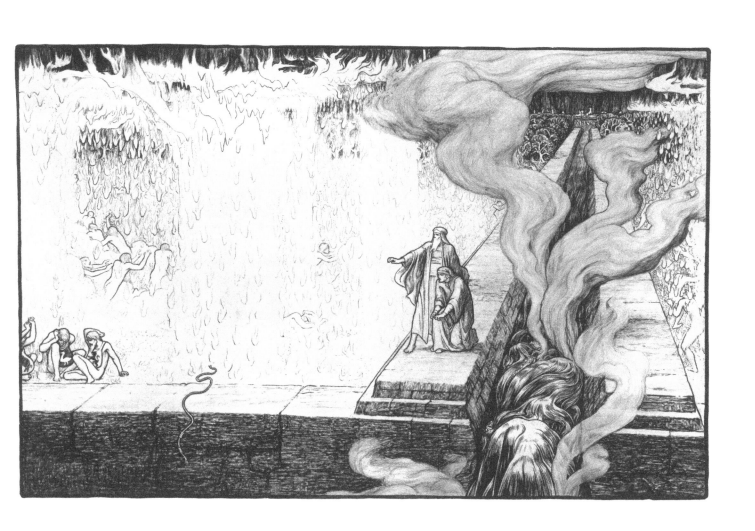

27

GERYON

One of Batten's most remarkable illustrations. He follows closely Dante's description of Geryon, 'that foul image of fraud' (17.7), as having the face of a just and kindly man and a serpent's body, with two hairy claw-like arms and the rest covered in elaborate knots and whorls. Batten shows the terrified Dante, supported by Virgil, being transported on his back through the darkness and looking down on hearing the noise made by the falls of the river Phlegethon. Their wheeling flight out over lower Hell will eventually bring them down at the foot of the Eighth Circle, where the fraudulent are punished in ten ditches (*bolgie*). Batten conveys a sense of the sheer scale of Hell, showing all the ditches and also the figures of the giants around the perimeter of the last circle. He says in a note that he has taken care to follow Dante's specifications in representing the lowest *bolgia* as much wider than the others.

> It goes off swimming slowly on its way,
> And circles down, which I can only tell
> From wind blowing in my face and from below.
>
> Now to the right I heard the torrent's noise
> As it crashed horrifyingly below,
> At which I turn my head downwards and look.
>
> And then I felt more nervous about falling,
> Since I could make out fires and could hear wailing;
> Hence I grip tight with my whole trembling body.
>
> (17.114–23)

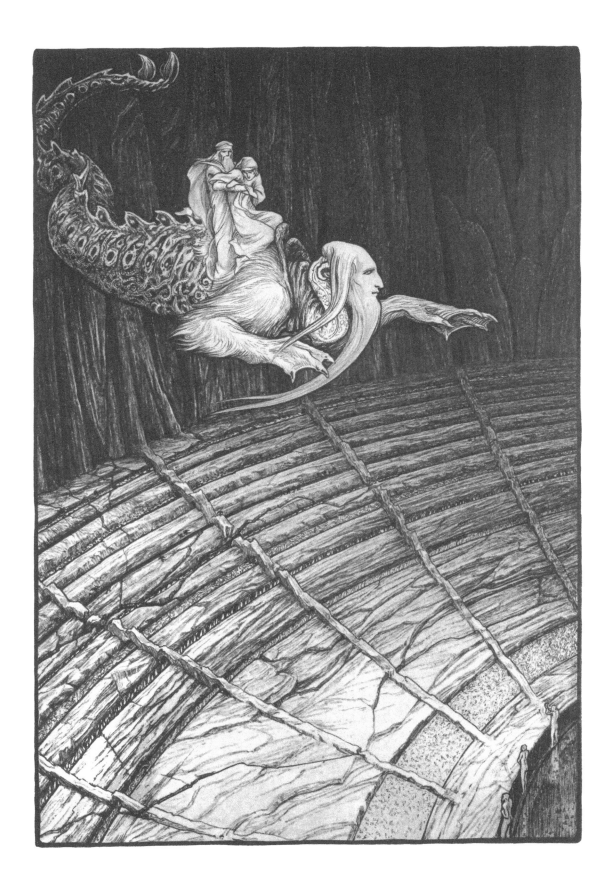

28

THE PANDERS AND SEDUCERS

Virgil and Dante are now in Malebolge, as the Eighth Circle, that of the Fraudulent, is called. It is constructed of rocks throughout, and traversed by series of rough bridges. Batten shows the two of them looking down from the first bridge into the first of its ten *bolgie*, where panders and seducers have to walk along at speed being constantly thrashed by devils, panders in one direction, seducers in the other. They have already seen the faces of the panders. Crossing over they can now see the seducers from the front, in particular the exceptionally resilient figure of Jason, who won the Golden Fleece but is punished for seducing and abandoning first Isiphile and then Medea.

> We looked down from the old bridge on the line
> Coming towards us in the other direction,
> Souls whom the lash drove on in the same way.
>
> And my good teacher said, without being asked,
> 'Look at that great one coming along now,
> Who does not seem to shed a tear from pain.
>
> How royal is the aspect he retains!
> That is Jason, who had the skill and courage
> To leave the Colchians without their ram.'

> (18.79–87)

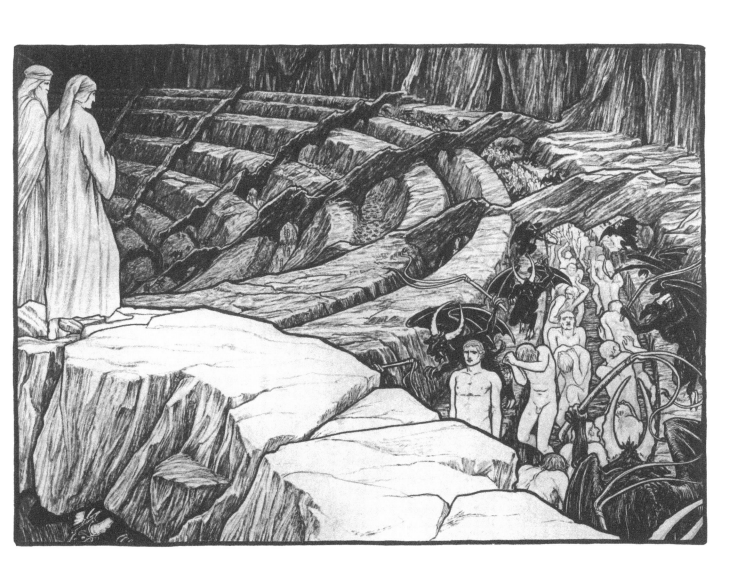

29

THE SIMONIACS

Batten omits the flatterers of the second *bolgia*, plunged in excrement, and passes on to the Simoniac clergy, that is, those who have abused their position for financial gain. They are plunged upside down in round black holes with their legs protruding and the soles of their feet aflame. Batten shows the moment when Dante has been taken down by Virgil nearer to a particularly active soul, who proves to be Pope Nicholas III. He initially mistakes Dante for Pope Boniface VIII, Dante's arch-enemy, who was still alive at the time of the journey.

And he called out, 'Already standing there?
Already standing there then, Boniface?'
The book I read was wrong by several years.

Are you so quickly sated with the wealth
For which you had the nerve to trick
The lovely bride and then to sell her off?

I found myself standing like one of those
Who do not understand what's been replied
And, being confused, do not know what to say.

Then Virgil said, 'Just tell him now straight off,
'I am not he, I'm not the one you think.'
And I gave the reply that I'd been told.

At this the spirit writhed his feet about,
Then, with a sigh and in a tearful voice,
Said to me, 'What do you then want of me?'

(19.52–66)

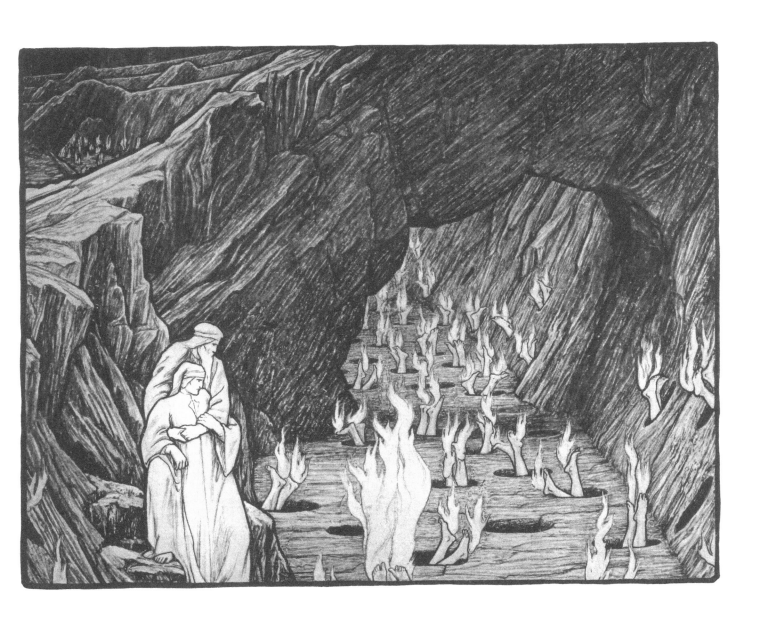

30

THE SOOTHSAYERS

The tips of the flames of the previous *bolgia* are still visible. But now Dante is looking down at the soothsayers and astrologers in the fourth *bolgia*. They dared to try to predict the future and now walk along in anguish with their heads twisted back to front. It is the moment when Dante himself weeps at the sight. But he is told by Virgil not to be a fool and to accept that here normal human pity has to be put aside and divine justice accepted.

> Perhaps because of some paralysis
> Some people have been twisted in this way,
> But I've not seen it, nor think it occurs.
>
> May God allow you, reader, to take fruit
> From what you read, if you think for yourself
> How hard it was to keep my eyes from weeping,
>
> When I saw close at hand our human image
> So twisted round that tears fell from the eyes
> To bathe the buttocks through the crack.
>
> In fact I wept, leaning against a rock
> In the hard cliff, causing my guide to say,
> 'So are you still one of those other fools?
>
> Here pity is alive when it is truly dead.
> Who is more criminal than someone
> Who cannot bear the judgement that's divine?'

(20.16–30)

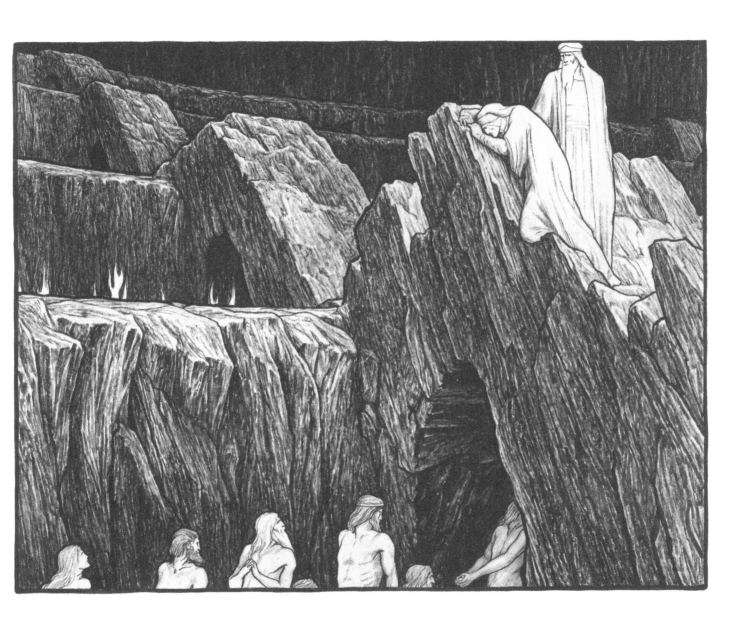

31

VIRGIL AND THE DEVILS

Dante and Virgil are now in the fifth *bolgia*, where the souls of corrupt politicians are plunged in boiling pitch while a host of devils with hooked gaffs make sure they keep below the surface. Virgil has told Dante to hide among the rocks of the bridge. He is now addressing the band of devils aggressively coming at him and explaining that Dante's journey is divinely sanctioned.

> With the wild fury and tempestuous rage
> That dogs show when they jump out at some wretch
> Who makes an unexpected stop to beg,
>
> Those devils came out from beneath the bridge
> And jabbed towards him their array of hooks.
> But he cried out, 'None of you be so wicked!
>
> Before these gaffs of yours take hold of me,
> Let one of you advance and listen to me,
> And then you can decide about the hooking.'

(21.67–75)

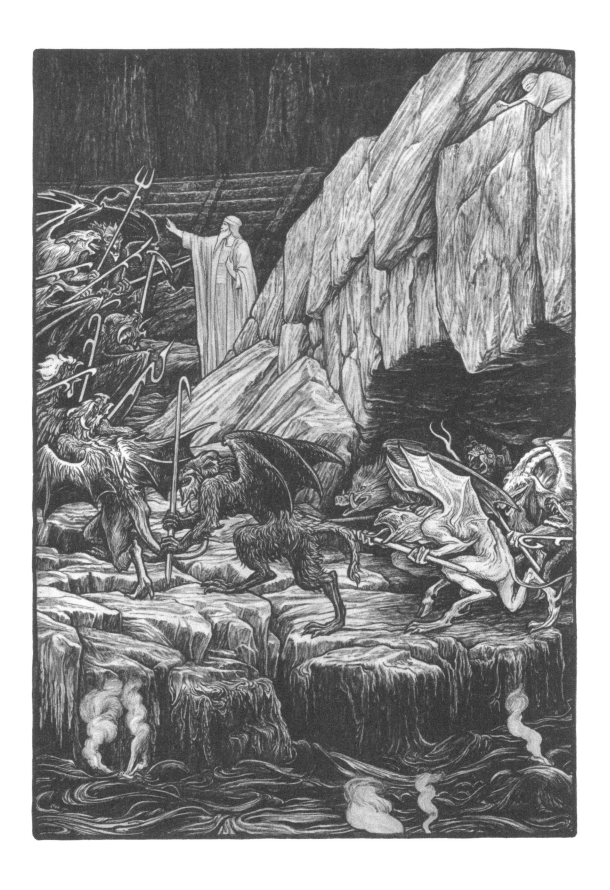

32

DEVILS IN THE PITCH

Two of the devils, Alichino and Calcabrina, have had a fight and ended up in the boiling pitch, unable to get out because their wings are all sticky. Batten shows the leader of the band, Barbariccia, with other devils on the right bank, calling out to four more who have just answered his summons and appeared on the left bank. Three of the figures are visible, the presence of the fourth being indicated only by his hooked gaff. The whole band are pulling at the two other devils, now thoroughly broiled, with the gaffs they normally use to keep the sinners below the surface. Dante and Virgil take advantage of the confusion to escape. Their figures are just visible in the top right-hand corner.

> Barbariccia, grieved as were his colleagues,
> Had four of them fly down the other side,
> Gaffs at the ready, and very rapidly
>
> All were in place on this side and on that.
> They held the hooks out to the ones enmired,
> By now well cooked beneath the pitch's crust.
>
> And we left them to their entanglement.

(22.145–51)

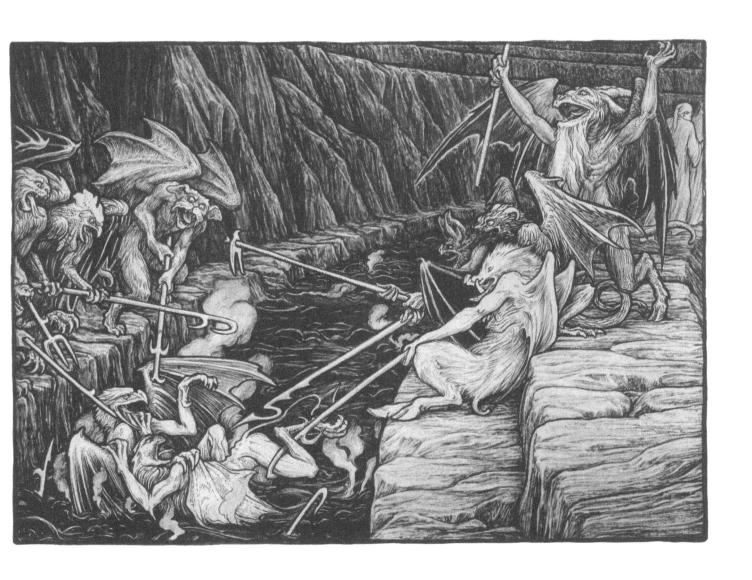

33

CAIAPHAS AND THE HYPOCRITES

Though the devils' instruments can still be seen above them, Dante and Virgil are now in the sixth *bolgia*, that of the hypocrites. Their penalty is to keep walking while wearing immensely heavy hooded robes which are shining gold on the outside and lead within. The naked bearded figure on the ground is Caiaphas, the priest of the Pharisees, who advocated surrendering Jesus for punishment as a matter of public order. He now lies there himself, crucified and trodden on by all the other hypocrites as they walk on, as are, elsewhere in the *bolgia*, other members of the guilty council. Batten shows the moment when Dante has just learned his identity from one of the other hypocrites, Fra Catalano, and realises that Virgil is amazed by the sight. Though Dante does not say why, we may guess it is because the punishment is inflicted by a divine justice which he as a pagan did not know in life.

> He said, 'The staked one you are looking at
> Advised the Pharisees that they should let
> One man be put to death for the whole people.
>
> He is laid out, naked, across the road,
> As you can see, and is compelled to feel
> How much each weighs before they travel on.
>
> And his wife's brother is similarly beset
> Here in this ditch, like others from the council
> That was the seed of evil for the Jews.'
>
> I noticed then that Virgil was amazed
> To see the figure stretched out, crucified
> So sordidly in everlasting exile.

(23.114–26)

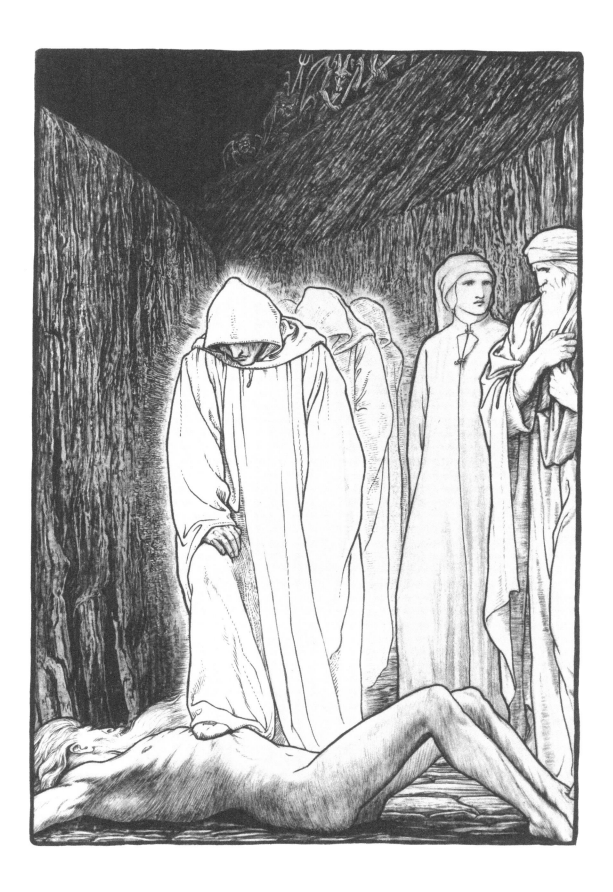

34

CLIMBING OUT OF THE SIXTH *BOLGIA*

Virgil and Dante have learned from Fra Catalano that the bridge over the sixth *bolgia* is broken. They have therefore to climb up the rocks to get out. Batten shows the shining figures of the hypocrites struggling on below and Virgil and Dante now nearing the top of the ridge, which, as Dante says, is a little lower than the one before but at least as steep. Dante is completely out of breath and can barely force himself to continue. Virgil stands above, telling him in no uncertain terms to pull himself together and keep going if he wants to produce any lasting work.

> My breath had been so squeezed out from my lungs
> That once up, I could go no further on,
> And instead straightaway sat myself down.
>
> 'Now is the time to shake off laziness,'
> My teacher said, 'for sitting on a cushion
> Does not bring fame, nor lying in bed either.
>
> He who just wastes his life not thinking of it
> Leaves as much trace behind him on the earth
> As smoke in the air or foam on the sea.
>
> So stand yourself up. Conquer the exhaustion
> With the strong spirit that wins every battle,
> Unless it droops under the body's weight.
>
> There is a longer climb you'll have to make.
> It's not enough to have left those behind.
> If I make sense, turn my words to good use.'

(24.43–57)

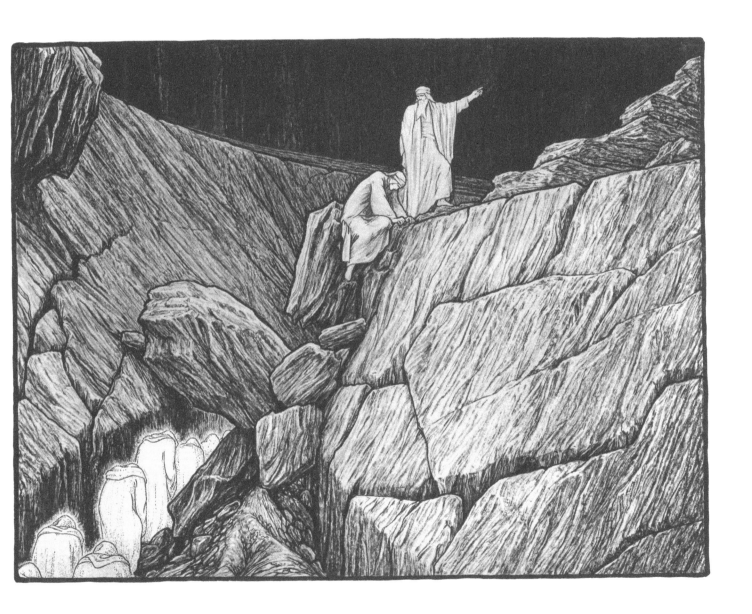

35

THE THIEVES

Dante and Virgil are at the edge of the seventh *bolgia*, that of the thieves. Poisonous snakes and dragon-like creatures are shown in the background on the left, wrapping themselves round the upper parts of the sinners, one of whom is Cacus, the satyr-like thief killed by Hercules, re-imagined by Dante as a centaur. Immediately before him the horrified Dante sees a small serpent (as he calls it, though he imagines it looking more like a lizard) pouring smoke from its mouth towards a sinner who is now himself pouring back smoke from his navel where the beast has bitten him. The two are staring at each other. The serpent will now take on human form and the human will be transformed into serpent, which Batten indicates is already starting to happen. On the right a composite beast resulting from the fusion of a snake and a sinner is leaving the scene. Behind it is a further terrified figure, who Dante says was the only one out the group of five (all Florentines) not to be transformed in some way.

> Just as a lizard under the great lash
> Of summer's hottest days, changing hedges,
> Seems lightning as it flies across the road,
>
> So now appeared flashing up to the bellies
> Of the other two, a little fiery snake,
> Of a dull blackness like a peppercorn.
>
> And it bit at that part of one of them
> Through which we take our earliest nourishment,
> Then dropped down flat and lay in front of him.
>
> The bitten one just stared, but did not speak,
> Or rather, standing there, he gave a yawn,
> As if sleep or a fever were upon him.
>
> He stood watching the snake, and the snake him.
> Smoke billowed from the wound of one, and from
> The other's mouth, and the two smoke clouds merged.
>
> (25.79–93)

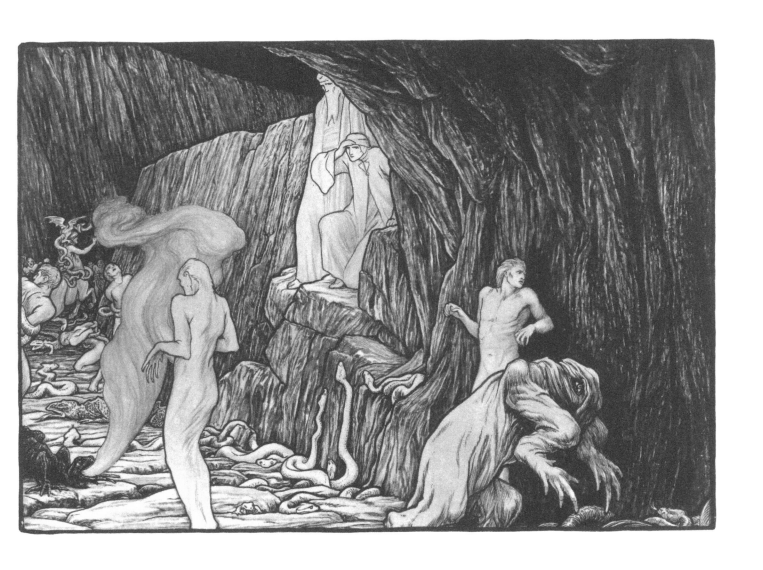

36

ULYSSES AND DIOMEDES

Dante and Virgil are on the rocky bridge over the eighth *bolgia*, in which the souls of fraudulent counsellors are enveloped in tongues of flame. Virgil has identified a double-tongued flame as containing the souls of Ulysses and Diomedes, who are punished together for crimes they committed as a pair during the Trojan War. Dante is especially drawn to them and Virgil has asked them to come and speak. Batten keeps close to Dante's description of how he leans forward to hear while keeping a firm grip on the rock to stop himself falling. The longer of the two tongues of flame is shown stirring into movement as Ulysses begins to tell the story of his final voyage.

> The greater of the ancient flame's two horns
> Started to shake and make a murmuring sound
> Just as a flame does that a wind disturbs.
>
> Then waving its top part this way and that,
> As if it were the tongue itself that spoke,
> It threw words out into the air, saying, 'When
>
> I took my leave of Circe who detained me
> More than a year there near to Gaeta,
> Before Aeneas gave the place that name,
>
> Not pleasure in my son, nor due concern
> For an old father, nor the debt of love
> That should have made Penelope rejoice,
>
> Could overcome the passion that I felt
> Deep in me to gain knowledge of the world,
> Of human vices and of human strengths …'

<div align="right">(26.85–99)</div>

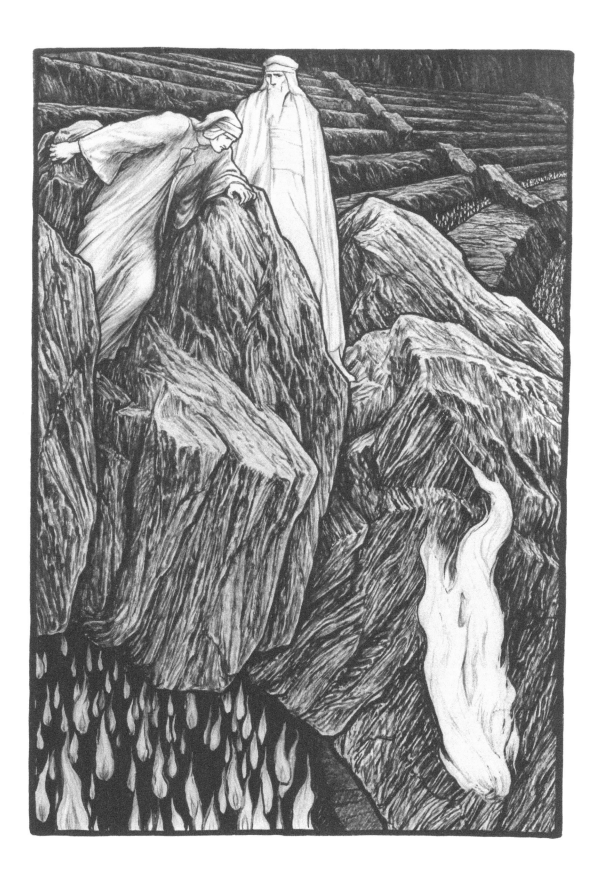

37

THE SOWERS OF DISCORD

Dante and Virgil are seen coming down the bridge over the ninth *bolgia*, in which the sowers of discord are punished by being themselves torn part. On the left is Bertrand de Born, the Provençal poet and lord of Hautfort, who set the English king Henry II against his son. Since he separated the political head and its body, his own head is now separate from his body. But Batten gives pride of place to Dante and Virgil, catching the moment when Dante wants to stop and weep at what he has seen. He is also concerned about a cousin of his father, Geri del Bello, punished here, who died violently and whom he feels he should have avenged. Virgil is shown turned to catch sight of Geri on the right side of the bridge pointing threateningly at the distracted figure of Dante. He will tell Dante to stop worrying about him.

> My master said then, 'Do not let your thoughts
> go straying any further over him.
> Focus on other things, and leave him there.
>
> I saw him at the foot of this small bridge
> Pointing at you and threatening with his finger,
> And heard the name Geri del Bello called out.
>
> But you were so completely taken up
> By him who was the lord of Hautfort once,
> You did not look that way until he'd left.'

(29.22–30)

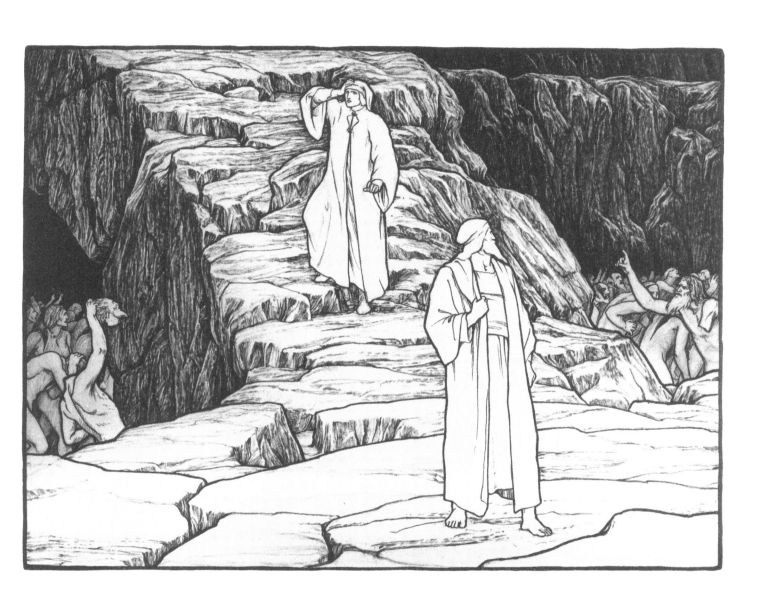

38

LEAVING THE EIGHTH CIRCLE

Dante is shown following Virgil over the bridge above the tenth and last *bolgia* of the Eighth Circle, under which are sketched in the forms of the many souls punished there. They are counterfeiters and are rolling round on the ground tormented by various diseases, mostly of the skin. Dante puts his hands over his ears because he has heard a terrifyingly deafening blast on a horn, louder than that blown by Roland after Charlemagne's defeat at Roncesvalles. He will learn shortly that the horn is that of Nembrot, who comes into view with the other giants in the next image. Again, Batten takes care to give an idea of the scale and geography of Hell, showing in the background the various causeways leading down over the *bolgie* to the ring of giants.

> We turned our backs upon the wretched valley
> Going up the bank that girds it all around,
> And made the crossing not speaking at all.
>
> Here it was not quite night and not quite day,
> So that my eyes could not see far in front,
> But then I heard so loud a horn ring out,
>
> It would have made a thunderclap seem weak.
> And following back the way it had come,
> My eyes were drawn towards a single point.
>
> After the agony of the great rout when
> Charlemagne lost his band of holy knights,
> Roland did not blow such a fearsome blast.
>
> (31.7–18)

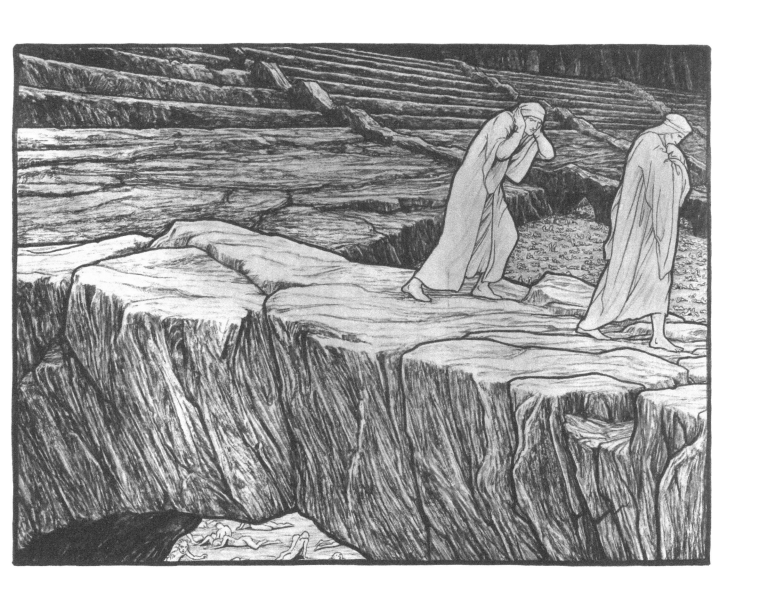

39

THE GIANTS

Dante and Virgil do not appear in this image. Instead, Batten depicts the cracked floor of the Eighth Circle sloping down to the ring of giants, with the walls of the causeways on either side. Dante compares them as they emerge into view with the towers that existed in his time round the walls of the citadel of Monteriggioni, near Siena. The minute upper bodies of the counterfeiters in the last *bolgia* of the Eighth Circle in the immediate foreground contrast with the massive upper bodies of the giants, who are standing with their feet resting far below on the floor of the Ninth Circle, as in a well. The giant with the horn is Nembrot or Nimrod, the main creator of the tower of Babel. To his left is the chained figure of Ephialtes, who was one of the giants who tried to storm Olympus, the seat of the gods of Greece and Rome.

> For just as on its circle of round walls
> Monteriggioni wears a crown of towers,
> So over the bank built up round the well
>
> There towered up with just half of their bodies
> The horrifying giants, whom Jove still
> Threatens from heaven when his thunder roars.
>
> And I began to make out now the face of one,
> And then his shoulders, chest, most of his belly,
> And both the arms he held down by his sides.
>
> Certainly nature, when she stopped devising
> Beings of this sort, performed a virtuous act
> In taking such accomplices from Mars.
>
> (31.40–51)

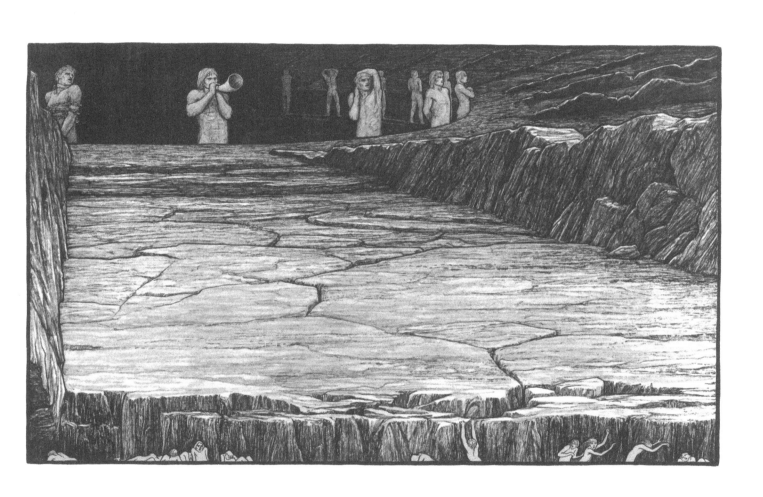

40

ANTAEUS

Nembrot is blowing his horn on the left, the chained Ephialtes is twisted round and the third giant, Antaeus (who is freer than the others because he did not join their revolt against the gods) is carefully depositing Dante and Virgil on the ice of the Ninth Circle, having been persuaded by Virgil to pick them up from the edge of the Eighth. Dante says that, before he is picked up, the sight from below of the giant's movements is like seeing the leaning tower of the Garisenda in Bologna from below when a passing cloud creates the illusion that the tower is moving, not the cloud.

> When Virgil felt the giant holding him,
> He said to me, 'Come here so I can hold you.'
> Then he drew both of us into a single bundle.
>
> As one looking up at the Garisenda
> Under the leaning side, feels, if a cloud
> Should pass by, that the tower is bending over,
>
> So Antaeus seemed to me, as anxiously
> I waited to see him bend, and that moment,
> I would have much preferred another route.
>
> But gently on the floor where Lucifer
> And Judas are devoured he put us down,
> Although he did not stay long bent like that,
>
> But rose up as the mast does of a ship.

(31.133–45)

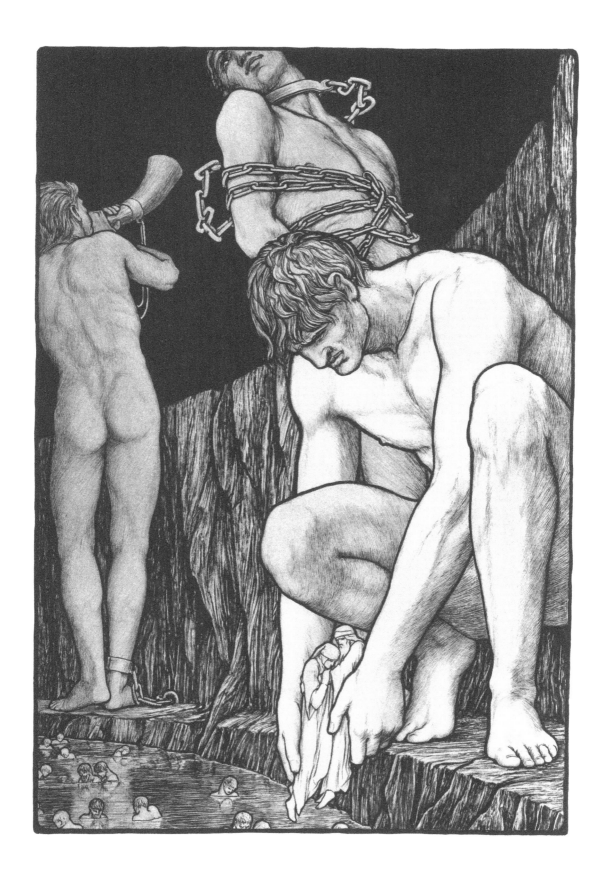

41

RUGGIERI AND UGOLINO

Fighting against the freezing wind created by Satan's wings, Virgil and Dante are making their way over the ice of the Ninth Circle, in which the souls of traitors are imprisoned. Behind them can be seen the legs of the giants around the circle's circumference. They have reached the part called Antenora, which is dedicated to political traitors. They have spoken with one sinner, and now, looking down, Dante sees two more sinners in a single hole, one gnawing at the head of the other, much as Statius says the dying Cretan king Tydeus gnawed at the head of his enemy Menalippus. The sinner being gnawed is Archbishop Ruggieri and the gnawer is Count Ugolino. He is lifting his head to speak and will tell the story of his imprisonment and death in the next canto. For reasons we do not know this illustration was not included in the second edition of Musgrave's translation.

> We had now left that sinner some way back,
> When I saw two more frozen in one hole,
> One head upon the other like a hat.
>
> And just as someone starving eats his bread,
> So did the top one bite into the other,
> There where the brain joins with the spinal column.
>
> No different was the way that Tydeus gnawed
> At Menalippus' temples in his rage,
> From how he gnawed the skull and all the rest.
>
> <div align="right">(32.124–32)</div>
>
> He raised his mouth up from his savage meal,
> That sinner, wiping it against the hair
> Of the head that he'd damaged at the back.
>
> Then he began.
>
> <div align="right">(33.1–3)</div>

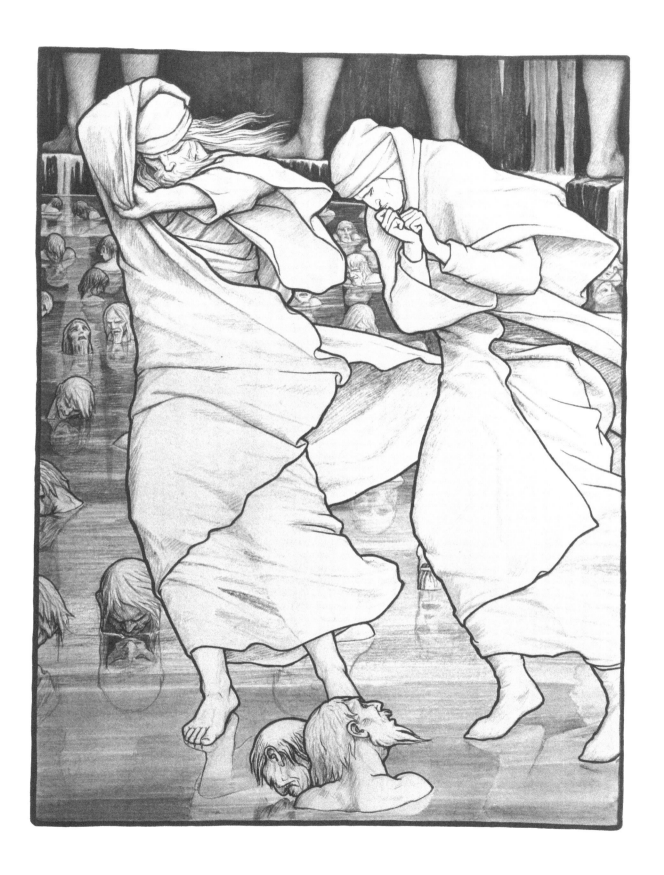

42

SATAN

The enormous figure of Satan rises up out of the glassy ice of Giudecca which covers entirely sinners guilty of betraying their lords. In the mouths of his three differently coloured heads – Batten's shading suggests the red, black and yellow specified by Dante – he is chewing on the three worst traitors in human history in Dante's view: Judas, who betrayed Jesus Christ, and Brutus and Cassius, who betrayed Julius Caesar. Batten shows a resolute Virgil with Dante sheltering behind him barely able to look, both being blown by the icy wind created by the slow beating of Satan's wings. As the figure becomes clearer, Virgil tells Dante what he sees, the first line of his speech being in Latin in the original ('Vexilla regis prodeunt inferni').

'The standards of the king of Hell advance
Towards us. So look at what is in front,'
My teacher said, 'if you can make it out.'

As at those times when a dense fog arises
Or when our hemisphere is darkened over
You might see far away a windmill turning,

So I seemed then to see some such machine.
Then, given the wind, I took refuge behind
My leader, for there was no other cover.

I was now, and I write these lines with fear,
Where all the souls were covered over
And clear to see as bits of straw in glass.

Some are laid flat and others are stood straight,
One head up and another upside down;
A third's face is bent bowlike to his foot.

(34.1–15)

102

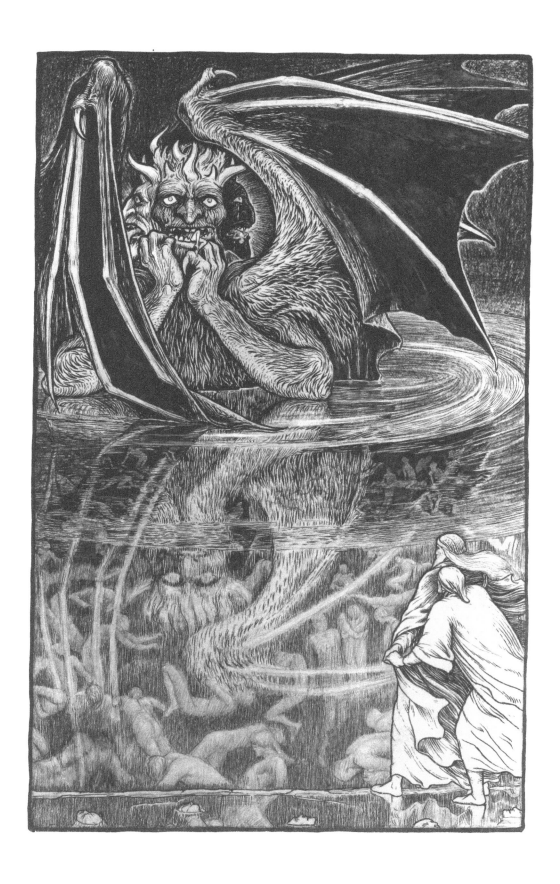

43

SATAN'S VIEW OF HELL

Dante emphasises the sheer size of the figure of Satan. Batten attempts to capture this with an image not in the poem itself. He shows Hell from a point just above Satan's head, which appears in the foreground, with the ends of his bat-like wings waving above it. Before him is the whole expanse of lower hell, with the steaming river Phlegethon pouring down from the Seventh Circle into the Eighth and the monster Geryon, who had carried Virgil and Dante down, perched halfway up the cliff on the right, minute in the distance. Below can be seen the divisions of the Eighth Circle, the last *bolgia* being shown correctly somewhat farther away from the others. In the nearer foreground are the giants, who now seem minuscule in comparison with Satan. Ephialtes is recognisable on the left from his chains. The concentric bands in the icy Ninth Circle indicate its four divisions.

> The emperor of the tormented kingdom
> Rose from the ice from halfway up his chest,
> And my proportions are more like a giant's
>
> Than those of giants compare with his arms.
> You can tell now how big must be the whole
> To conform with a part of such a size.
>
> If he was once as fair as now he's foul,
> And lifted up his eyes against his maker,
> All misery must truly come from him.

(34.28–36)

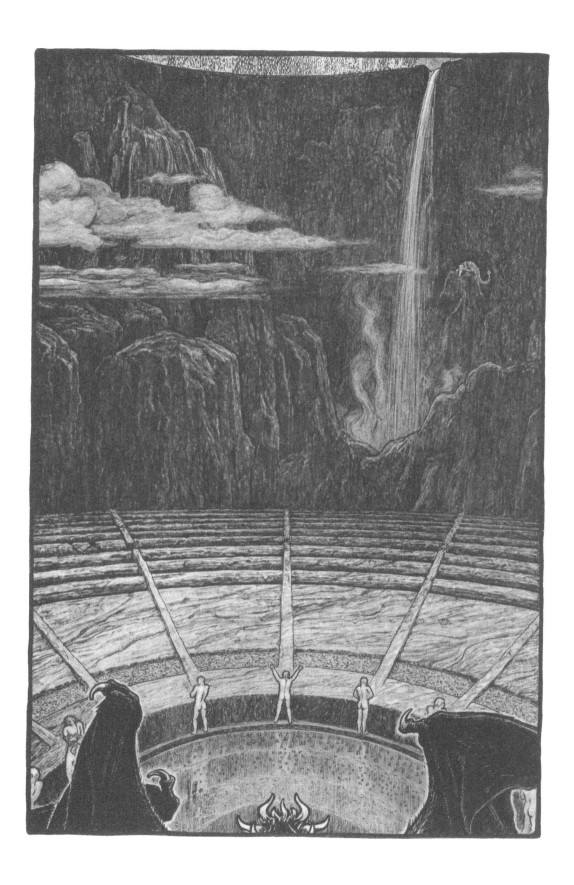

44

LEAVING SATAN

Virgil has clambered down Satan, with Dante holding onto him round the neck. At the centre of Satan's body and of the earth, he has turned upside down and brought the two of them up on the other side. They will now leave Hell via a narrow passageway. Dante takes a backward look, stunned to see Satan's enormous and monstrous hairy legs poking upwards, while Virgil pushes on forward, telling Dante that the sun is now well risen – it is, he says, halfway through the third canonical hour, that is, the time is around seven thirty in the morning.

> I raised my eyes and thought that I would see
> Lucifer appear as I had left him,
> And saw that he had both his legs held upward.
>
> If I was thrown in turmoil at that moment,
> That's something for slow minds to think about,
> Who don't see what that point was I had passed.
>
> 'Get yourself on your feet,' my teacher said.
> 'The way is long and the road difficult,
> And the sun halfway into tierce already.'

<div align="right">(34.88–96)</div>

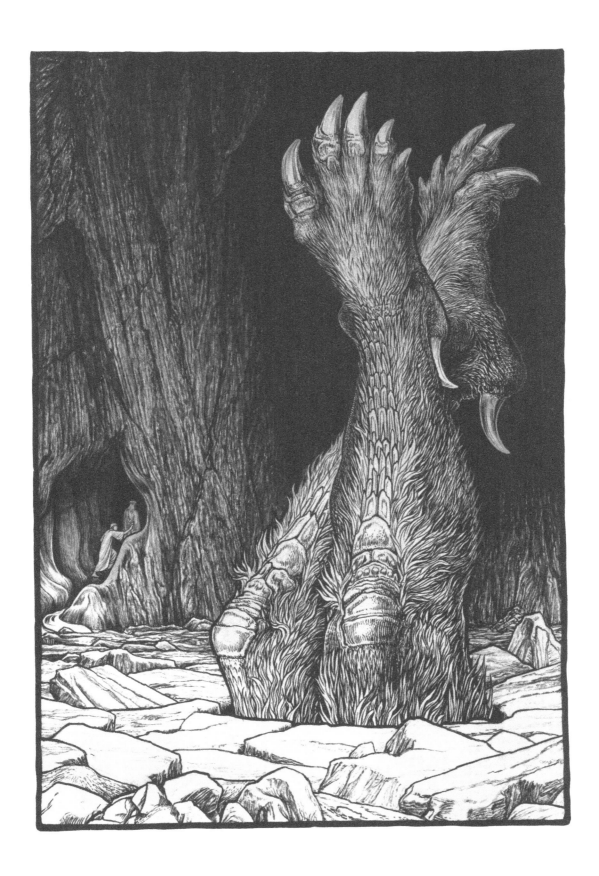

45

EMERGING TO SEE THE STARS

Virgil leads Dante up the sides of a deep pit, guided by the sound of a stream, shown pouring down on the right. This, Dante will learn at the end of his ascent of Mount Purgatory (28.25ff), is the river Lethe, which carries memories of sin from the purified penitents down to the proper place of sin, which is Hell. In this illustration to the final lines of the *Inferno*, Batten shows Virgil and Dante climbing out of the infernal dark to see the stars for the first time since the journey began. Dante will in fact look at the four stars shining brightly behind Virgil only at the start of *Purgatorio* (1.23–4). They are usually identified as signifying the four cardinal virtues (prudence, justice, patience and fortitude).

> I and my leader by that hidden way
> Passed out into the bright world once again.
> And with no thought of taking any rest,
>
> We climbed up, he first, myself following,
> Until I saw some of the lovely things
> Borne by the heavens, through a round aperture.
>
> Through it we left to see the stars again.

(34.133–9)

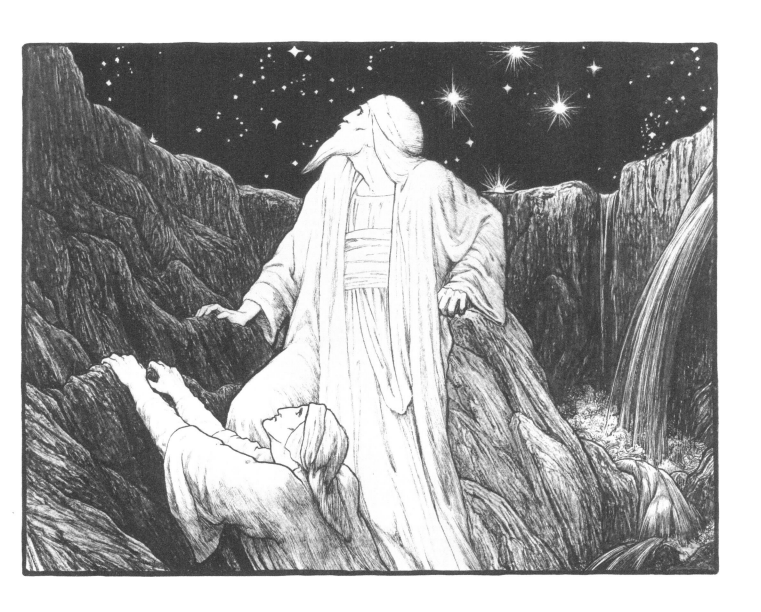

APPENDIX

46

EDMUND HORT NEW,
DANTE'S HELL

New's drawing gives a good impression of how the great funnel-shaped pit of Hell stretches down to the centre of the earth. The various circles are distinguished up to the Eighth Circle (Malebolge), the two lowest circles being presumably too complex to be represented in the small space left for them. As well as indicating various figures Dante meets (Charon, Minos, etc.), New shows Virgil and Dante at various points in their descent. He also gives a privileged position to the Noble Castle of Limbo. The place of Hell in the northern hemisphere is summarily indicated by the names in the four corners.

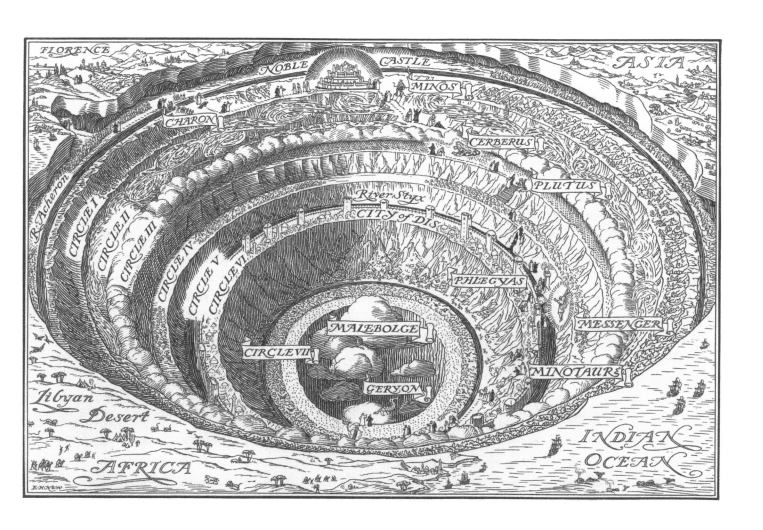

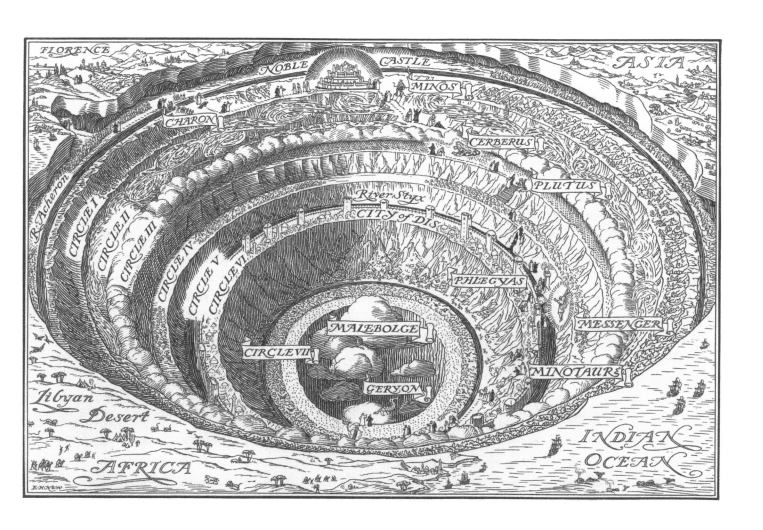

47

EDMUND HORT NEW,
DANTE'S WORLD

This second drawing by New shows Dante's overall conception of the world. The pit of Hell stretches down from the northern hemisphere to the centre of the earth. The mighty bulk of Mount Purgatory rises up on the other side, with the Earthly Paradise at its summit. The uninhabited southern hemisphere is otherwise covered by water.

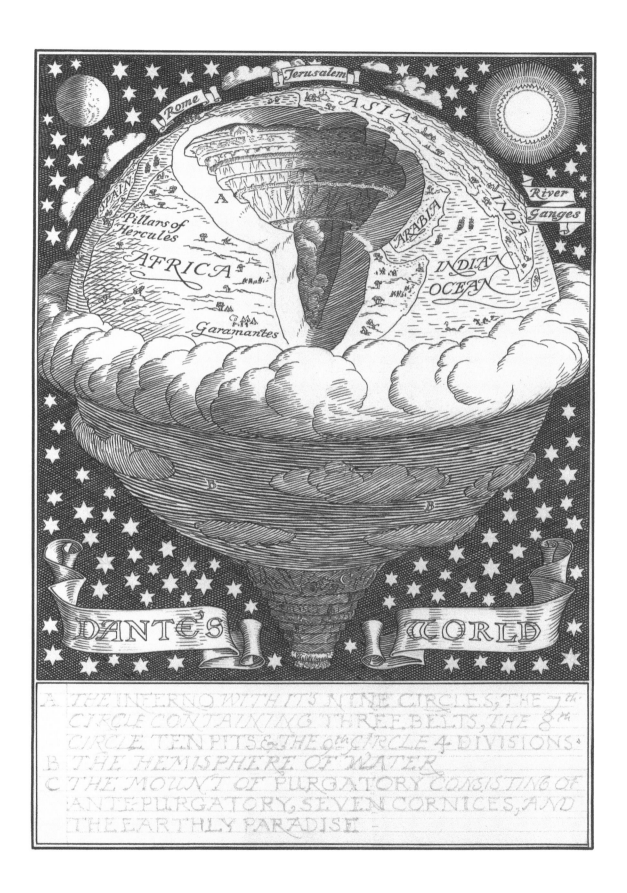

A. THE INFERNO WITH ITS NINE CIRCLES, THE 7th CIRCLE CONTAINING THREE BELTS, THE 8th CIRCLE TEN PITS & THE 9th CIRCLE 4 DIVISIONS.
B. THE HEMISPHERE OF WATER
C. THE MOUNT OF PURGATORY CONSISTING OF ANTE-PURGATORY, SEVEN CORNICES, AND THE EARTHLY PARADISE —

48

FREDERIC, LORD LEIGHTON, PORTRAIT OF DANTE

George Musgrave apparently intended this portrait of Dante by Frederic, Lord Leighton to be the frontispiece for his *Inferno* translation. Though perhaps more lined and careworn than usual, the features of Dante are much more like those with which we are familiar from countless other representations of him than those of the more youthful figure who appears in Batten's drawings.

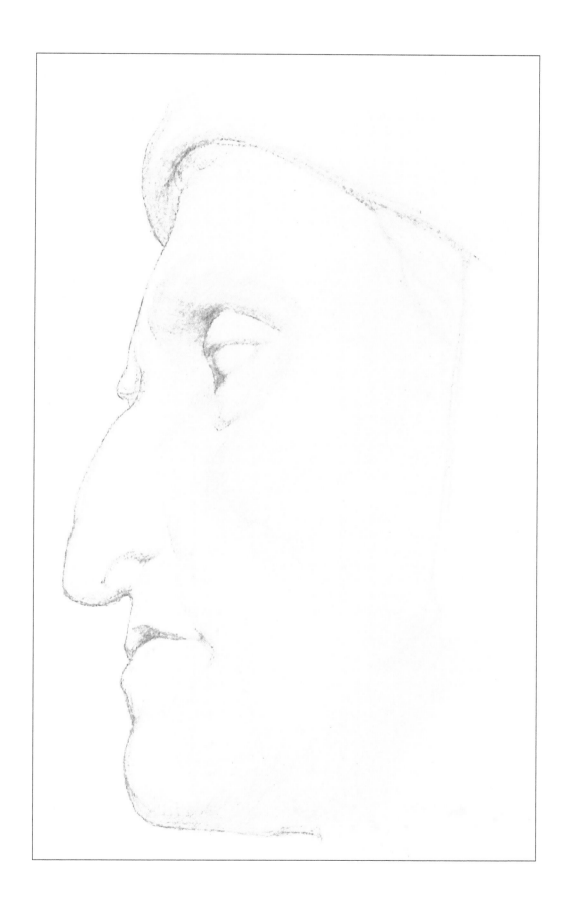